KEN That's a difficult question to answer. In a way, it is easier to say something about the topics not dealt with. In general, there really was not a lot of work that dealt with many of the most serious issues – dare I say crises – confronting the world today. I am thinking here of issues related to citizenship in the age of globalisation, war, rich and poor or geo-political topics. There was a lot of work that zeroed in on highly particularised yet common manifestations of the everyday. I would say there was almost a fetish of the inscription of micro-politics onto some quotidian activity, a bit of a misreading of Michel de Certeau for instance. I think there was a lot of complacency in what I saw. In my opinion, there seemed a wholesale giving up of a lot of difficult and complex topics in favour of a more spatially circumscribed topic. I kept thinking that maybe many young artists don't see art as the proper arena for effecting change in the social and political milieu, so why bother to express something that doesn't change anything. And they may be right, however unwitting they may have been to arrive at such a position. I found my experience as a juror a rather despairing one.

FRANCIS [to Ken] Your response raises the issue of the cultural legacy of May 1968; in fact, the selection took place around the time of the fortieth anniversary of the events. Do you think the political disengagement you detect in the work says more about educational institutions or wider contexts in the art world? Coming back to de Certeau's idea of 'everyday life', could you expand on the kind of tactics you saw being used in some individual pieces?

KEN As is well known, de Certeau's intellectual thought was greatly shaped by the events of 1968. His most celebrated period of thought, post 1968, marks the collapse of revolutionary and polymorphic fervour sublimating radical impulses into gestures of tactics and strategies. In response to your question concerning political disengagement, I think it is a condition that is more endemic to Western art schools and Western contemporary art. Of course, it is not an absolute condition but it is an endemic one.

As to your demand for an example, here is one. It is a video work. The first image is of the surface of water in a swimming pool. The camera shot is stationary recording only the gentle rippling of the water's surface. It was readily predicted by the jurors that something or someone would float into view and then possibly float out of view, the denouement being a return to the stationary image of rippling water. This is precisely what happened.

De Certeau is used as an intellectual cover in the sense of evoking a residual political intention in the most banal of expressions but de Certeau is also completely misunderstood in the sense of the work's utter predictability.

FRANCIS The situation Richard described could be characterised in terms of a service provider-client contract. What kind of space does this model allow for criticality? Does it have any advantages over a more traditional master-pupil relationship? Also, drawing on your selection notes, could you talk about some of the work in the show?

KEN Well, the traditional master-pupil relationship continues to be very strong in places such as China and certainly it is like that in Germany as well where students are accepted or not as part of a professor's class. I am not all that familiar with the particular character of today's British art schools. One observation I can offer is that it seemed the best candidates were overwhelmingly London area art students. The disequilibrium in terms of quality between London art students and non-London art students was quite striking. To be fair, Glasgow School of Art also put in a good showing, but I wondered particularly whether London was always so strong compared to the rest of Britain. I don't really understand the weakness given the striking perspectives that can be offered from the regions. The work of Paul Bratt really stood out for being creative, funny, pointed, poignant and regionally derived. The best works were able to convey a composite of feelings in conjunction with something that looked visually interesting. Artists such as Gerd Hasler and Yoca Muta. Neither the topic nor the treatment needed to be new, which I think was a big trap for a lot of the young artists we saw. What was new was the generation of feelings based on true feelings on the part of the artist.

July – August 2008

Open to all final year undergraduates and current postgraduates of Fine Art at UK colleges and those artists who graduated in the year 2007.

Pio Abad

Adam Ajina

Allsopp & Weir

Guler Ates

Steve Bishop

Paul Bratt

Stewart Cliff

Beth Collar

Alexia de Ville de Goyet

Joe Doldon

Jeremy Evans

Anwen Handmer

Chris Hanlon

Gabriel Hartley

Gerd Hasler

Neil Hedger

Tyler Bright Hilton

Sam Holden

Alex Hudson

Peter Joslyn

Emmanuel Kazi Kakai

Eva Kalpadaki

Katharina Kiebacher

Rinat Kotler

Raakhee Lakhtaria

Andrew Larkin

Ian Law

littlewhitehead

Joseph Long

Jo Longhurst

Ellen Macdonald

Allison Maletz

Jane Maughan

Sarah Michael

Haroon Mirza

Yoca Muta

Gemma Nelson

Sachiyo Nishimura

Yo Okada

Joep Overtoom

Heather Phillipson

Patricia Pinsker

Giles Ripley

Constance Slaughter

Rita Soromenho

Naomi St Clair-Clarke

David Stearn

Nicholas Tayler

Esther Teichmann

David Theobald

Jason Underhill

Manuel Vazquez

Lara Viana

Jane Ward

Anita Wernstrom

Paul Westcombe

Jeanine Woollard

Pio Abad
Push Me, Pull You
Mixed media
Dimensions variable
2008

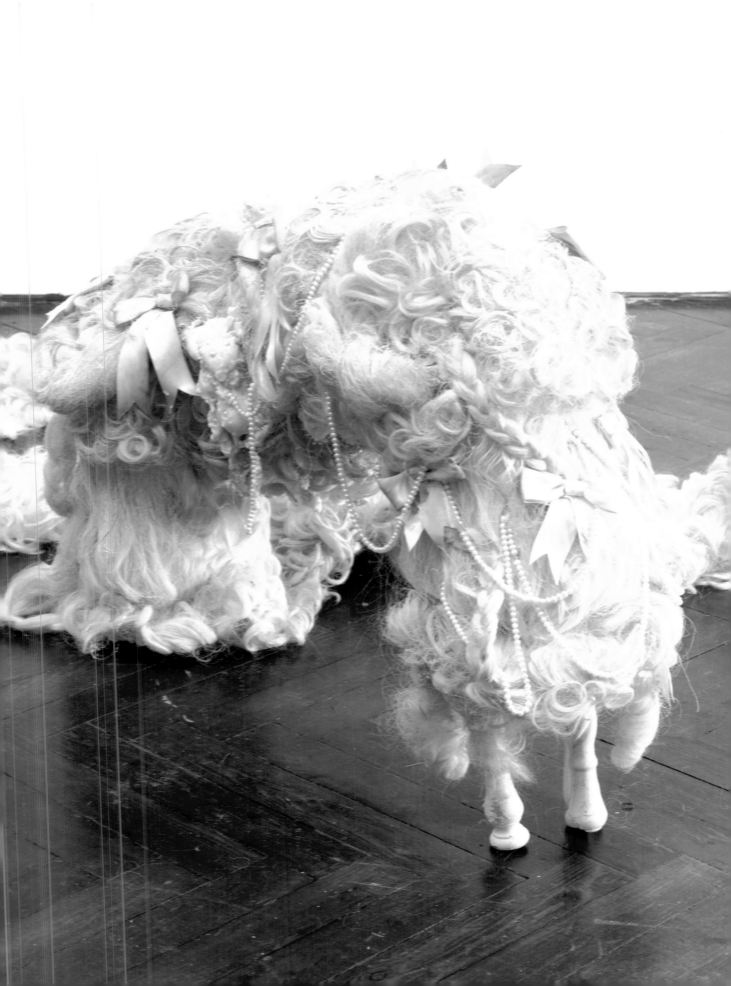

Adam Ajina
Fürsichsein (Steuergerät)
Detail of installation
Slide projector, medium format transparencies, polished stainless steel, bead-blasted
aluminium, silicone rubber, flush nut inserts, PCB laminate, PIC microcontroller,
capacitors, diodes, transistors, LEDs, switches, relays, miscellaneous fasteners & other
electronic components
2007 – 2008

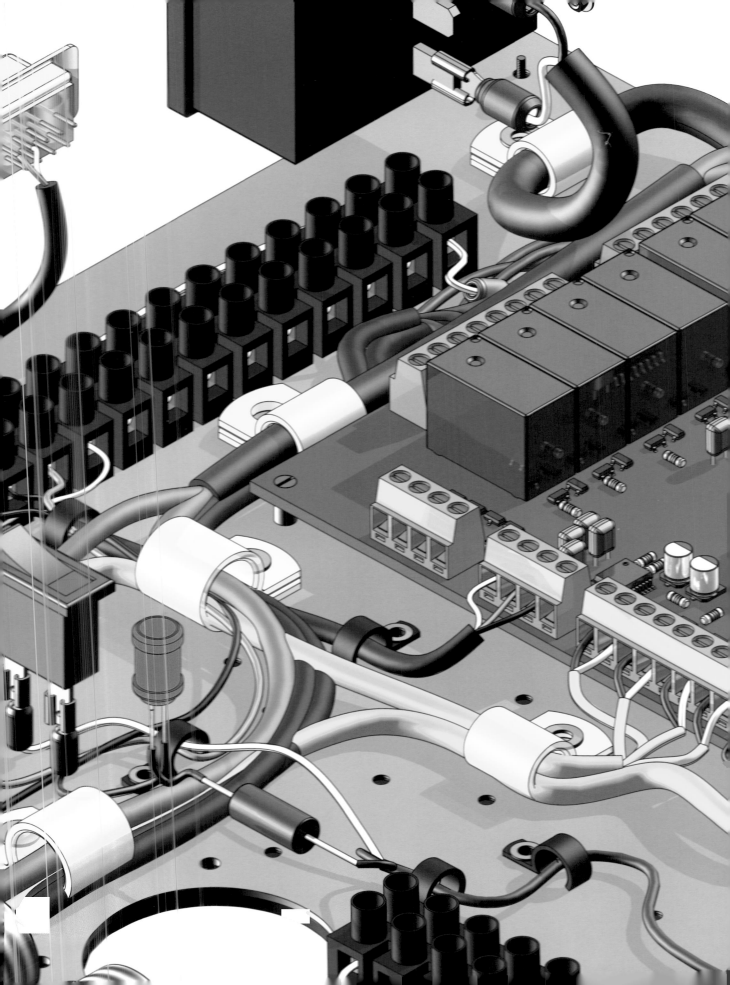

Allsopp & Weir
Amplification Device
DVD video
7 mins
2007

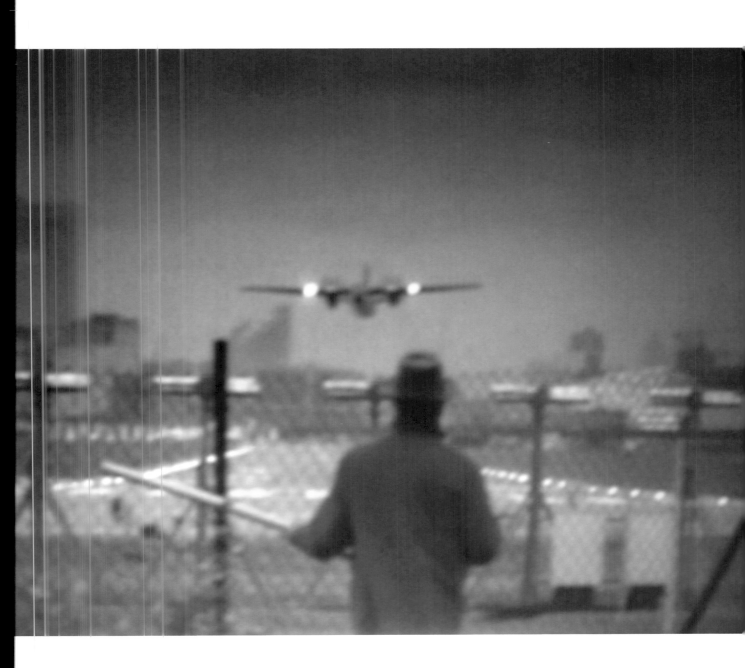

Guler Ates
The Night Chased The Day Chased The Night
DVD video
3 mins 25
2007

Steve Bishop
Suspension of Disbelief
Taxidermied fox, fluorescent tubes, electronic ballasts in wood and perspex housing, wires
170 x 170 x 160cm
2007
In the collection of J. Helgesen, Oslo

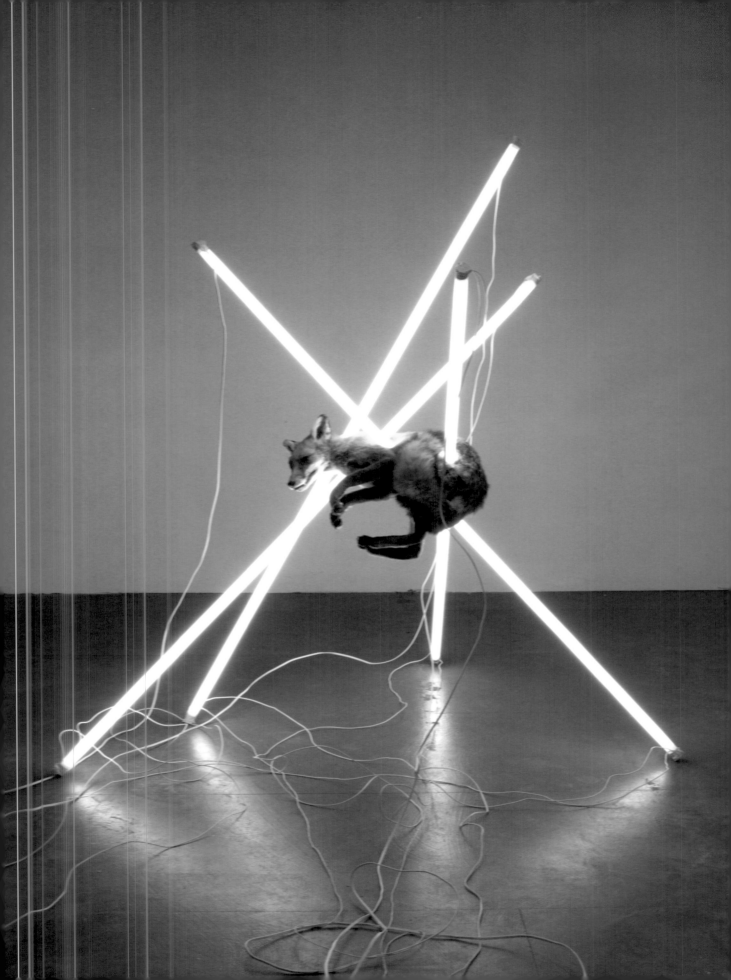

Paul Bratt
Heart
DVD video
6 mins 11
2007

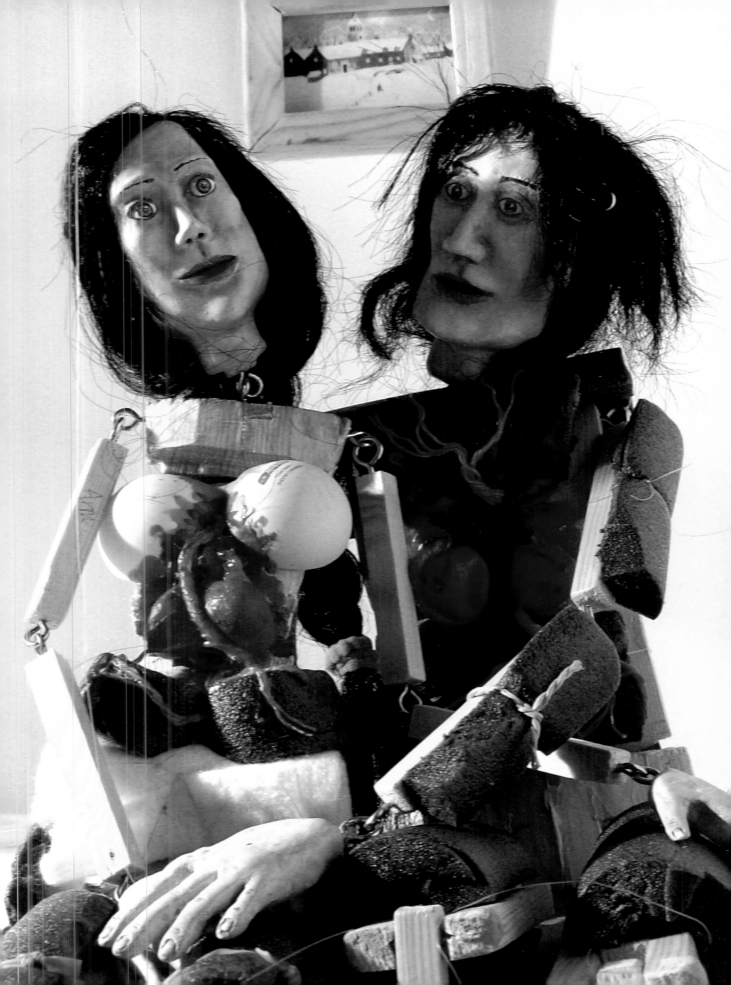

Stewart Cliff
Untitled
Oil on canvas
64 x 49cm
2007

Alexia de Ville de Goyet
Astral Chorus
DVD video
11 mins
2007

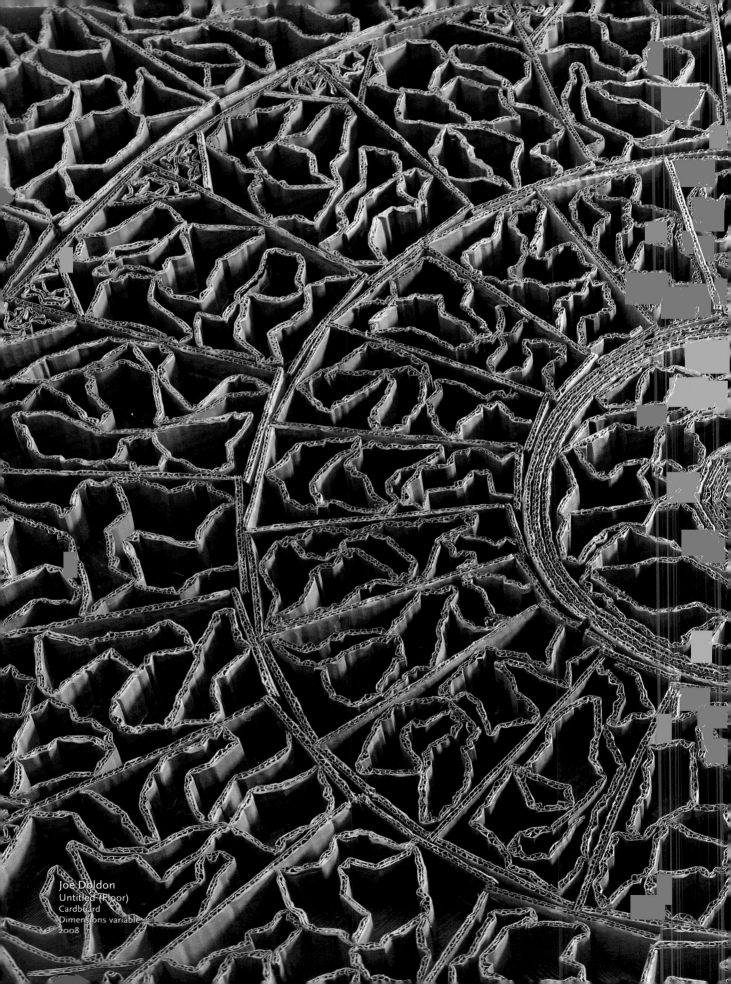

Joe Doldon
Untitled (Floor)
Cardboard
Dimensions variable
2008

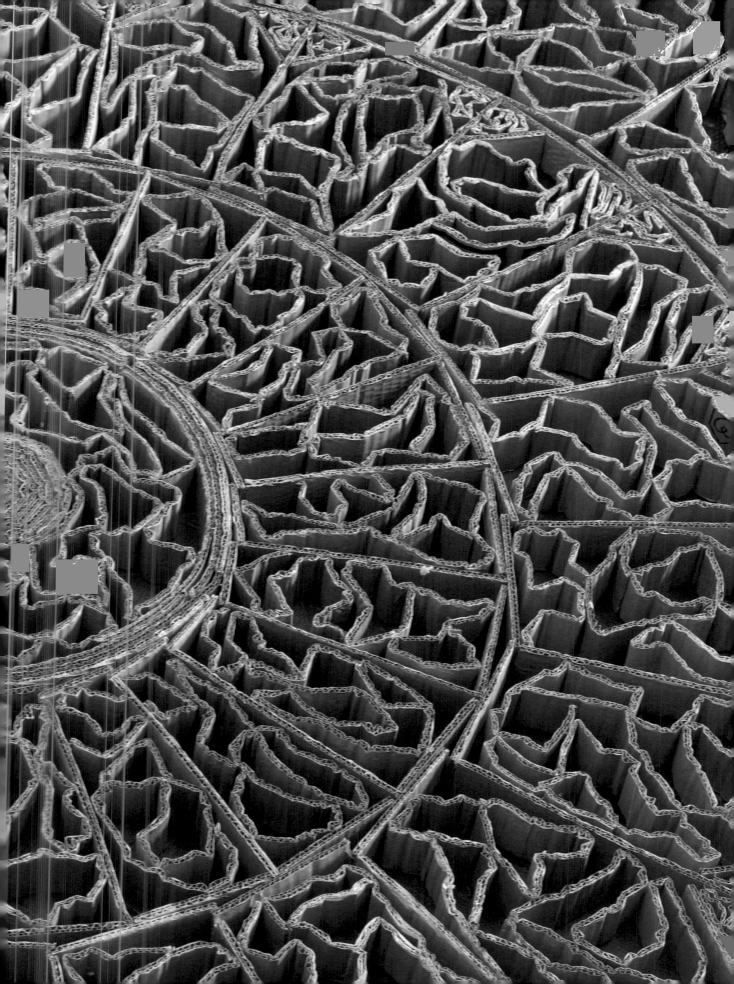

Anwen Handmer
Birthday Cake
Oil and wax on ply panel
120 x 120cm
2008

Gerd Hasler
monochrome #7
C-type print
144 x 180cm
2006

Gerd Hasler
Untitled, from the series Waterscapes
C-type print
180 x 144cm
2007

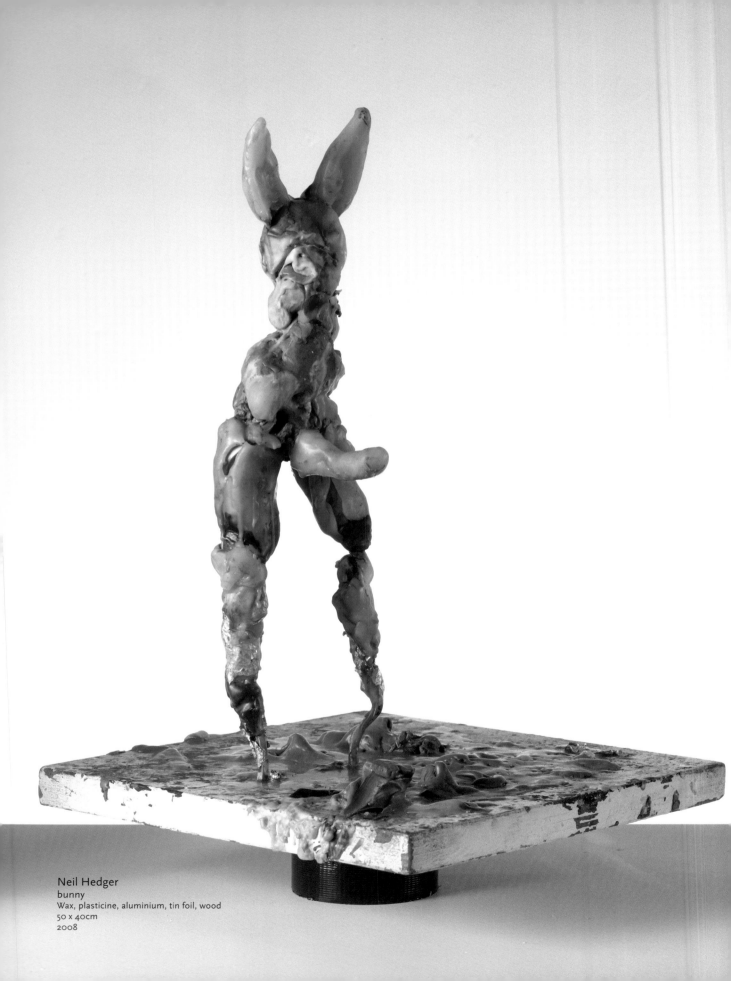

Neil Hedger
bunny
Wax, plasticine, aluminium, tin foil, wood
50 x 40cm
2008

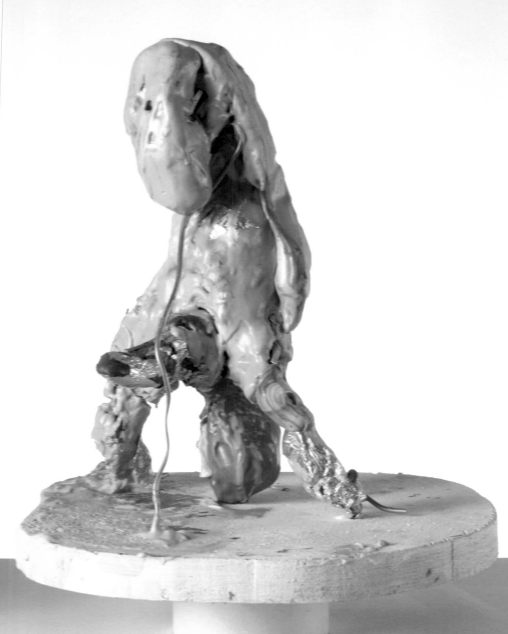

dogboy
Plasticine, tin foil, aluminium, chopping board
30 x 30cm
2008

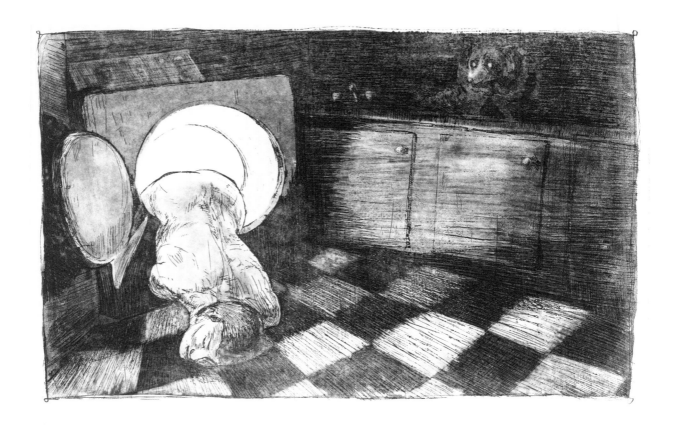

Chapter 10: In which our heroine recalls the previous night's delights.

Tyler Bright Hilton
Minmei Madelynne Pryor Went into the Dryer
Being a puzzling picture-story told in twenty parts, of a young lady of independent mind
Etchings
30 x 45cm each
2006 – 2007

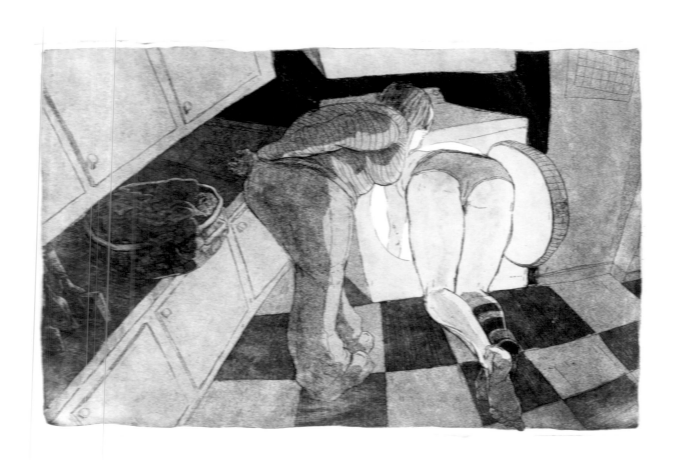

Chapter 12: In which Caitlynne is witness to a scene curious in the extreme.

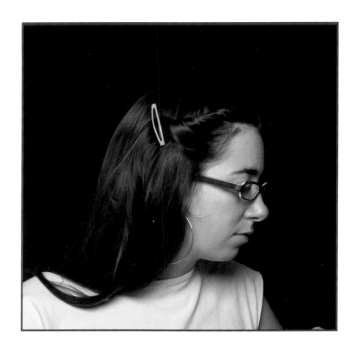

Sam Holden
70 Still Frames and 5 Minutes 50 Seconds of Video
Single channel video
5 mins 50
2007

Alex Hudson
Boy With Maracas
Oil on canvas
40 x 30cm
2007

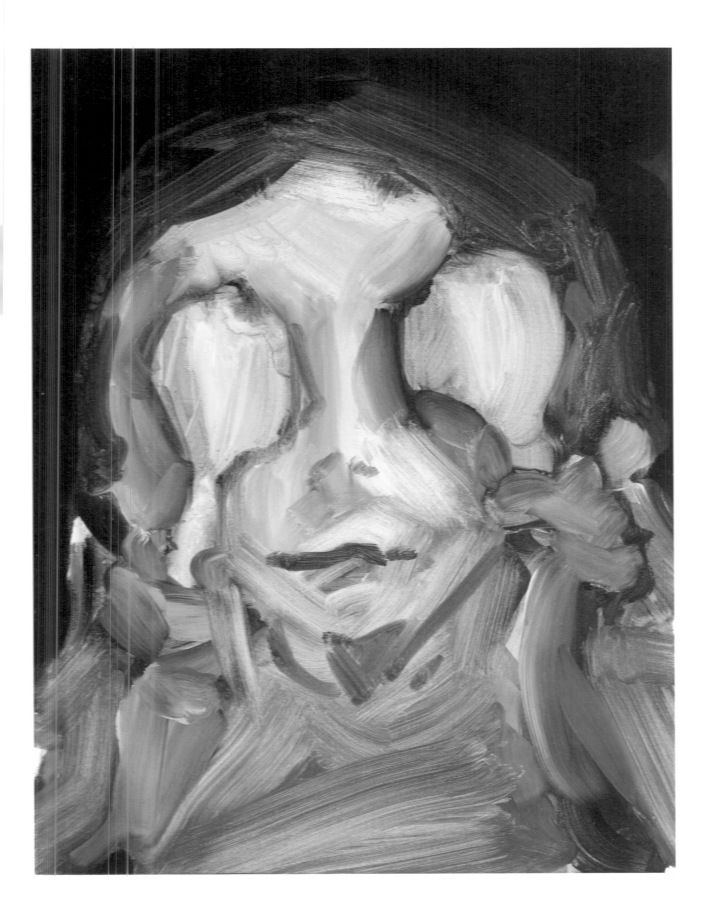

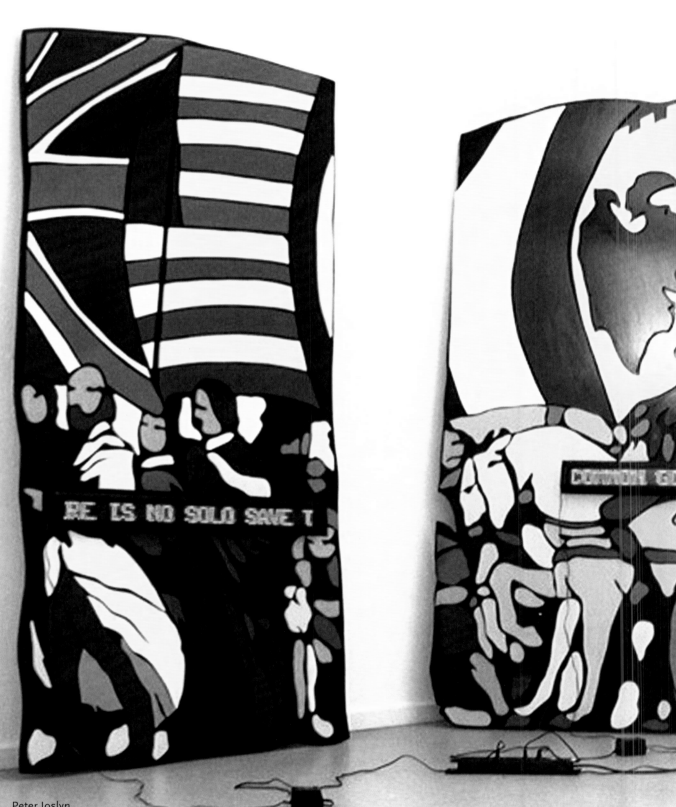

Peter Joslyn
L.A (Light Album)
Acrylic on MDF, LED message displays
3 panels each 240 x 120cm
2007 – 2008

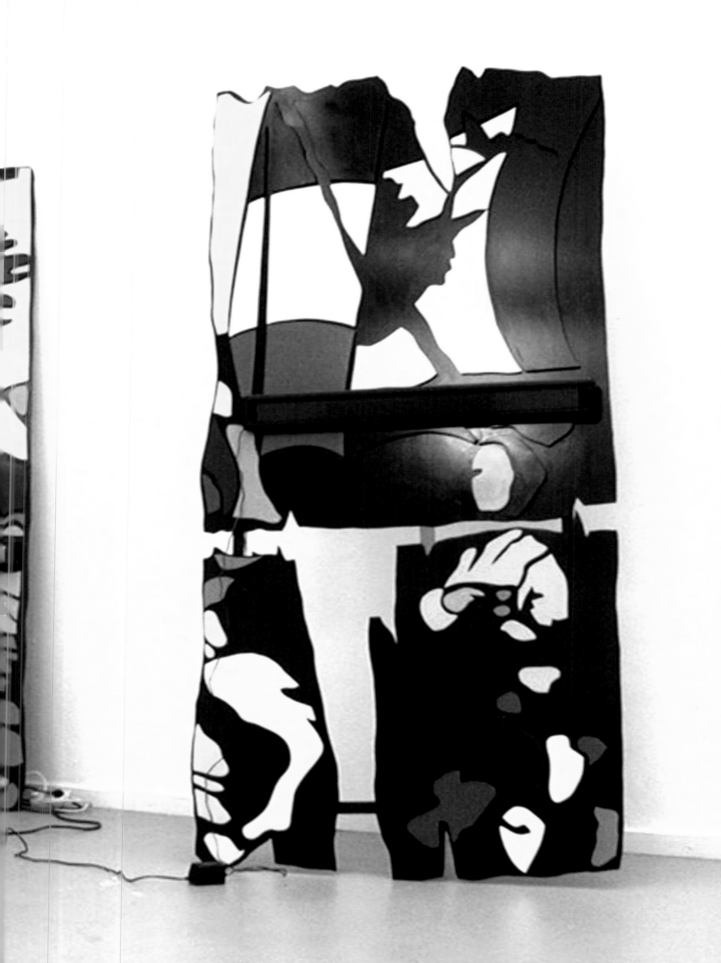

Emmanuel Kazi Kakai
Tooting, London
Recycled display cabinet, fishing line, sensor, motor, Arduino microcontroller
132 x 105 x 50cm
2007 – 2008

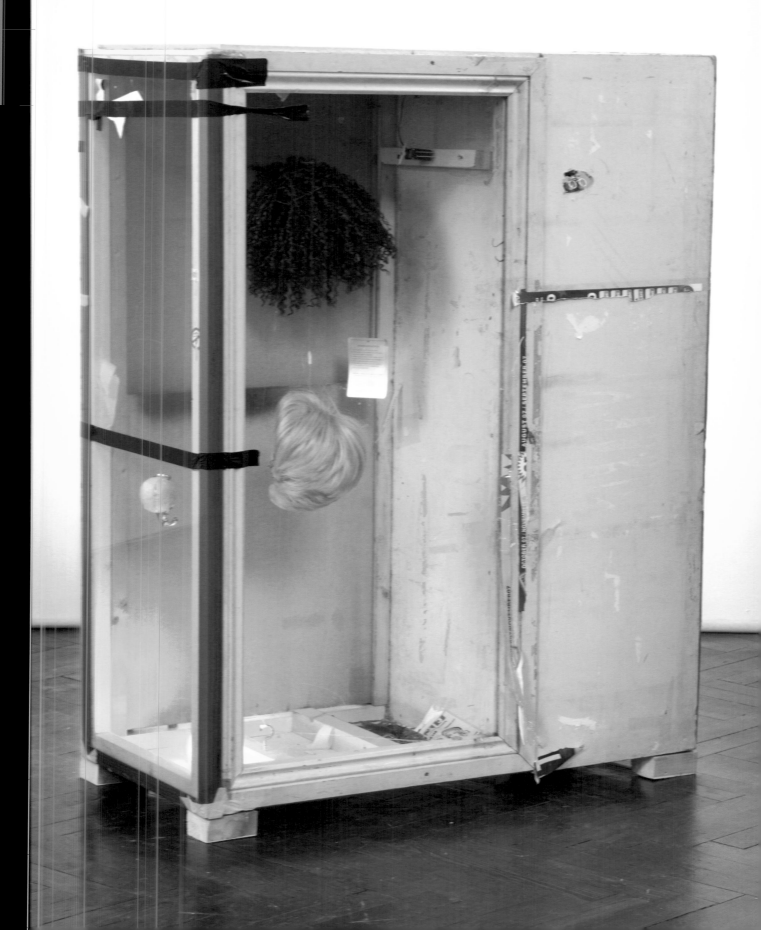

Eva Kalpadaki
Untitled 06 from the Empty Space series
Giclée print on Verona fine art paper mounted on aluminium
80 x 100cm
2005 – 2007

Katharina Kiebacher
Red Truck (2003)
C-type print
16 x 24cm
2003

Train with birds (2005)
C-type print
16 x 24cm
2005

Rinat Kotler
Babysitting
Video
5 mins 40
2007

So naturally I said lets cook him.

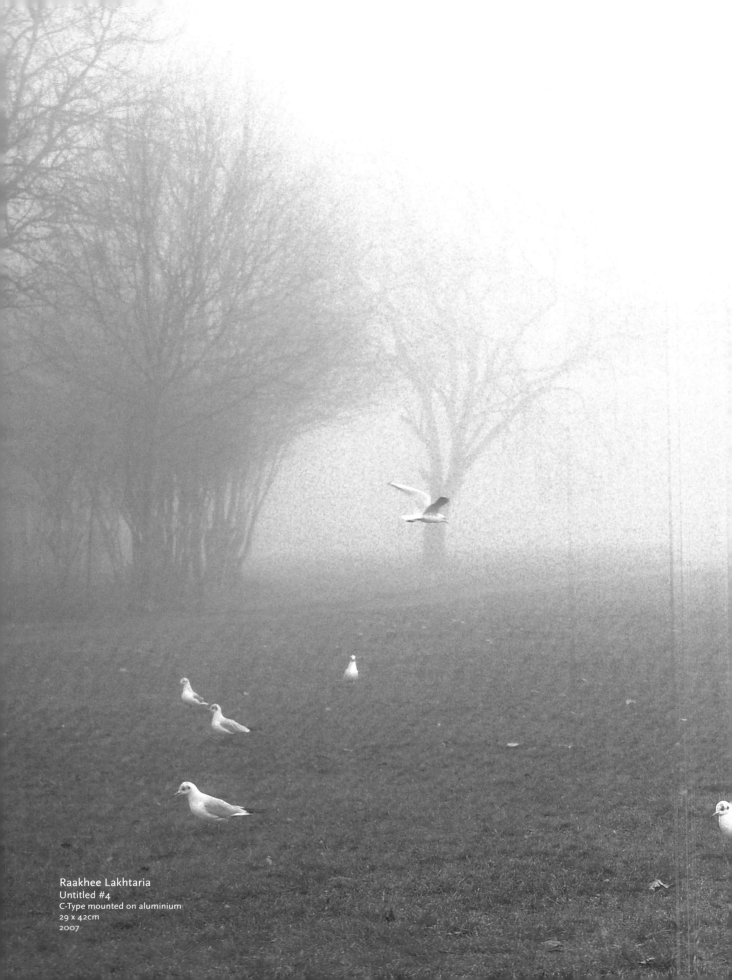

Raakhee Lakhtaria
Untitled #4
C-Type mounted on aluminium
29 x 42cm
2007

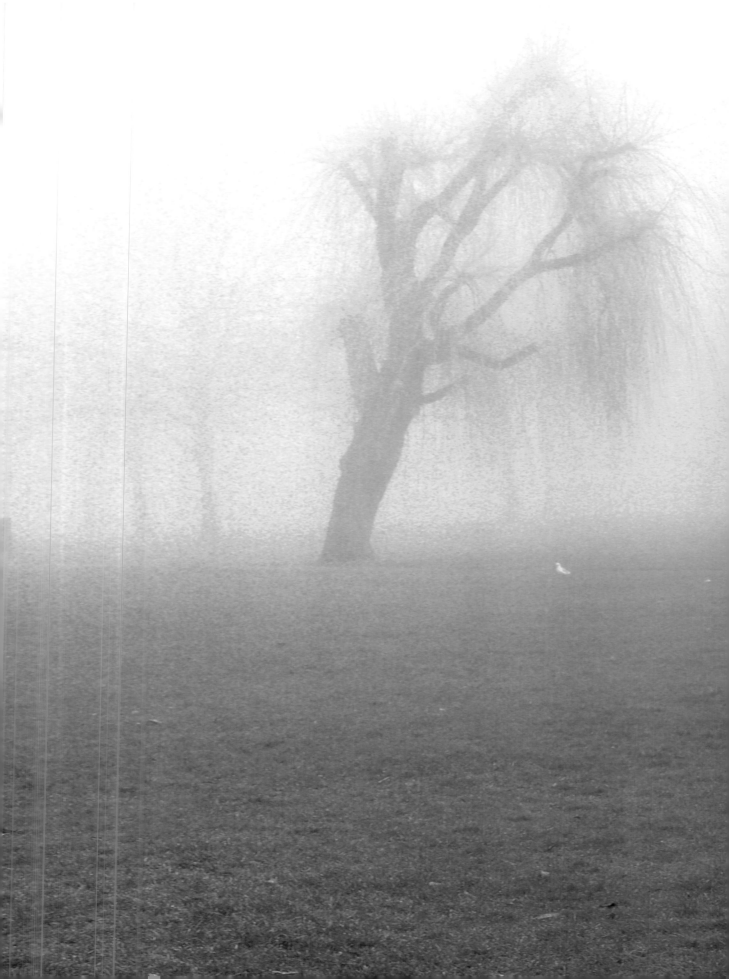

Andrew Larkin
Repetitive Strain Injuries 1-3
Silicon, plywood, pigment, 3744 soda glass tubes
240 x 70 x 12cm
2007

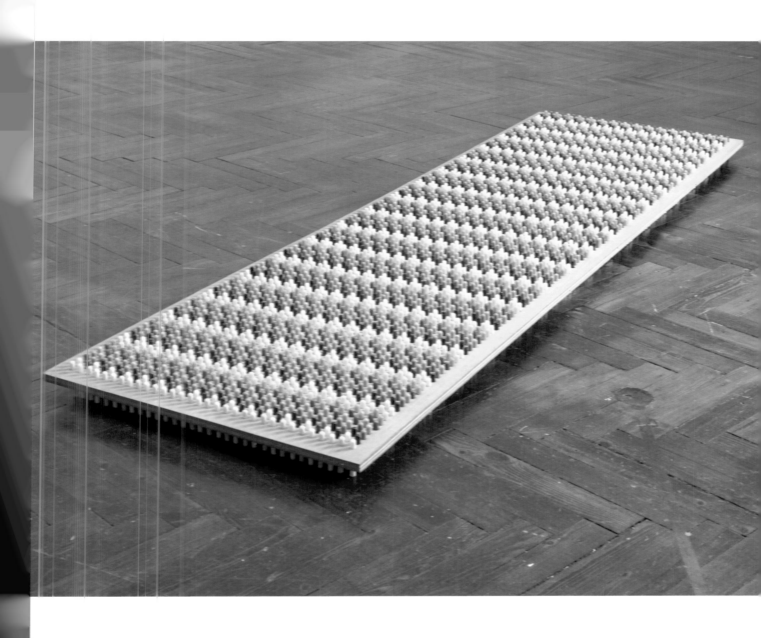

Ian Law
Overhead
Oil on board
42 x 51cm
2008

littlewhitehead
So Many Fellows Find Themselves
Plaster, wax, wood, clothes, chair
150 x 140 x 70cm
2007 – 2008

FOLLOWING SPREAD
It happened in the corner...
Plaster, wax, clothes
200 x 150 x 180cm
2007

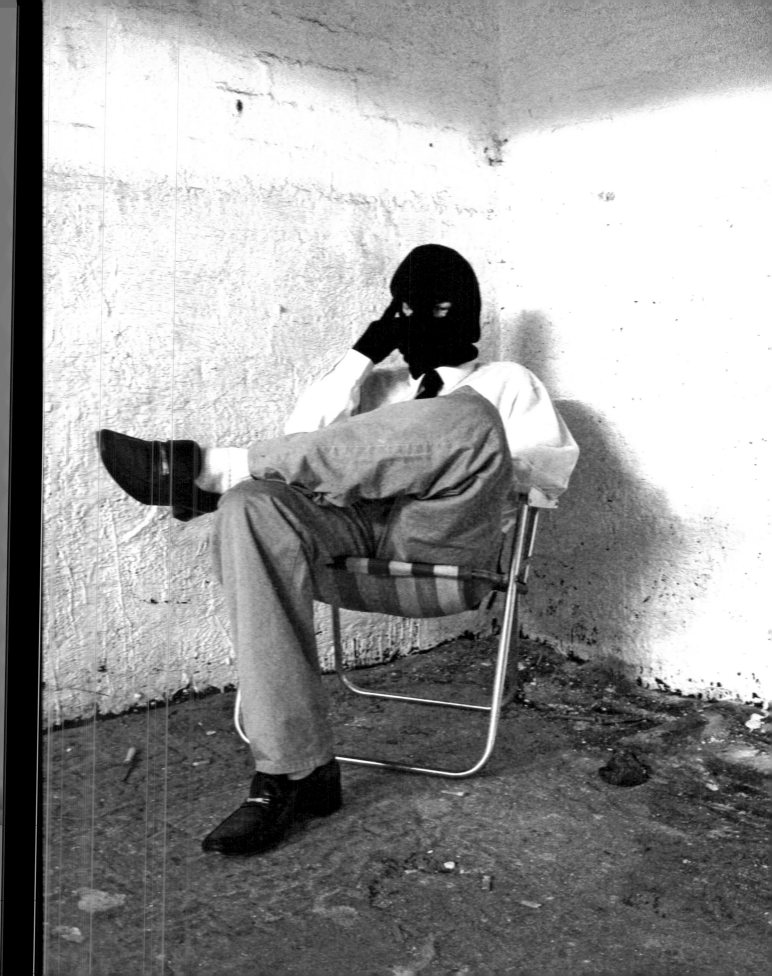

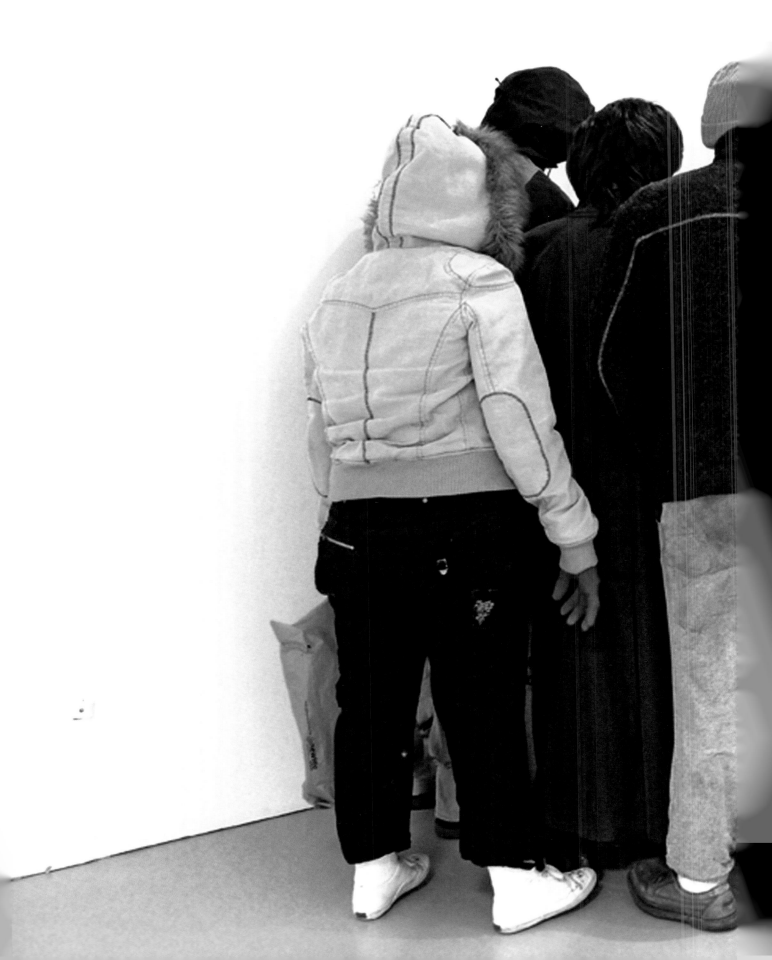

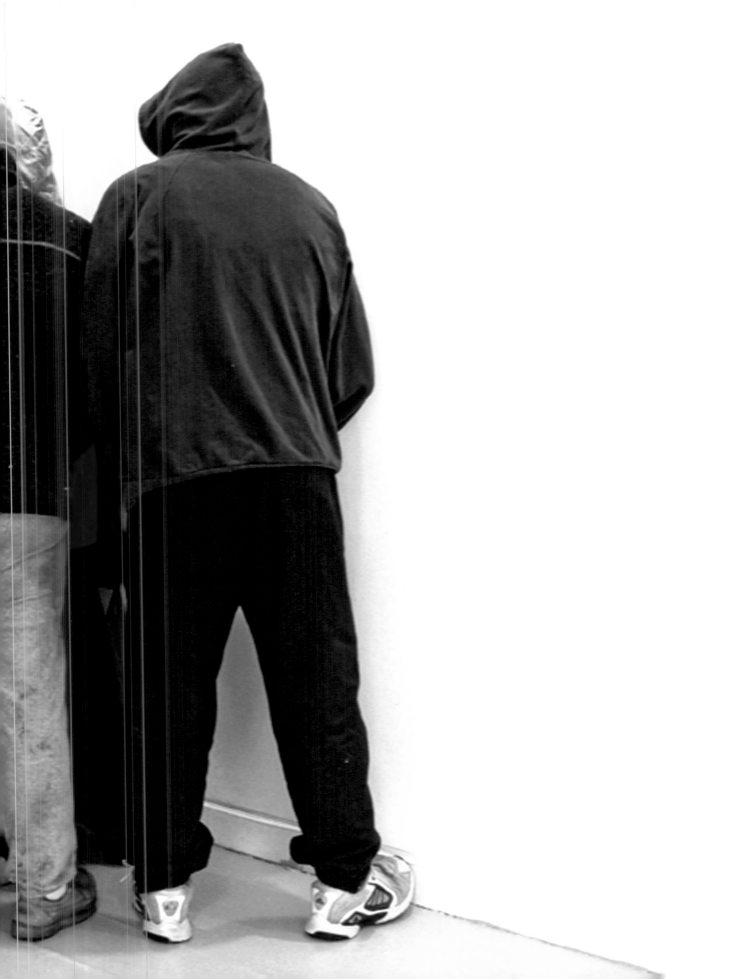

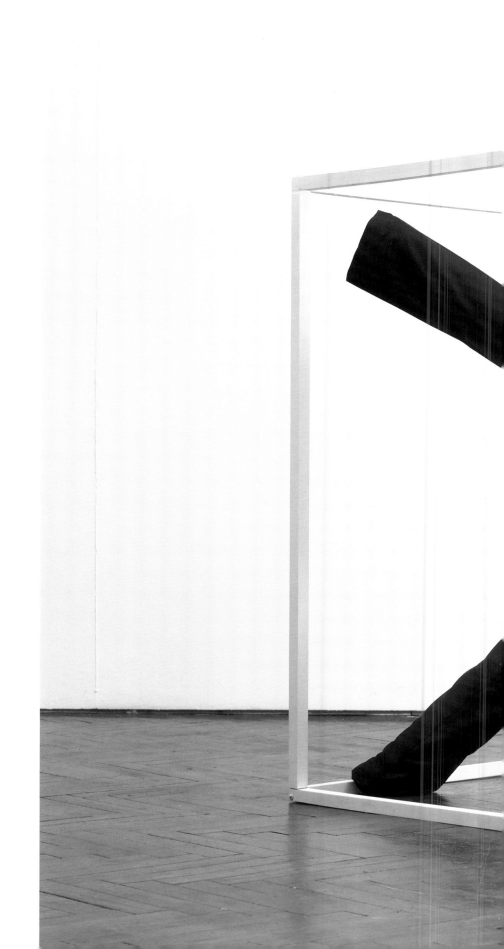

Joseph Long
Uni-titled
Suits, synthetic hair, wire, wood
152 x 152 x 152cm
2008

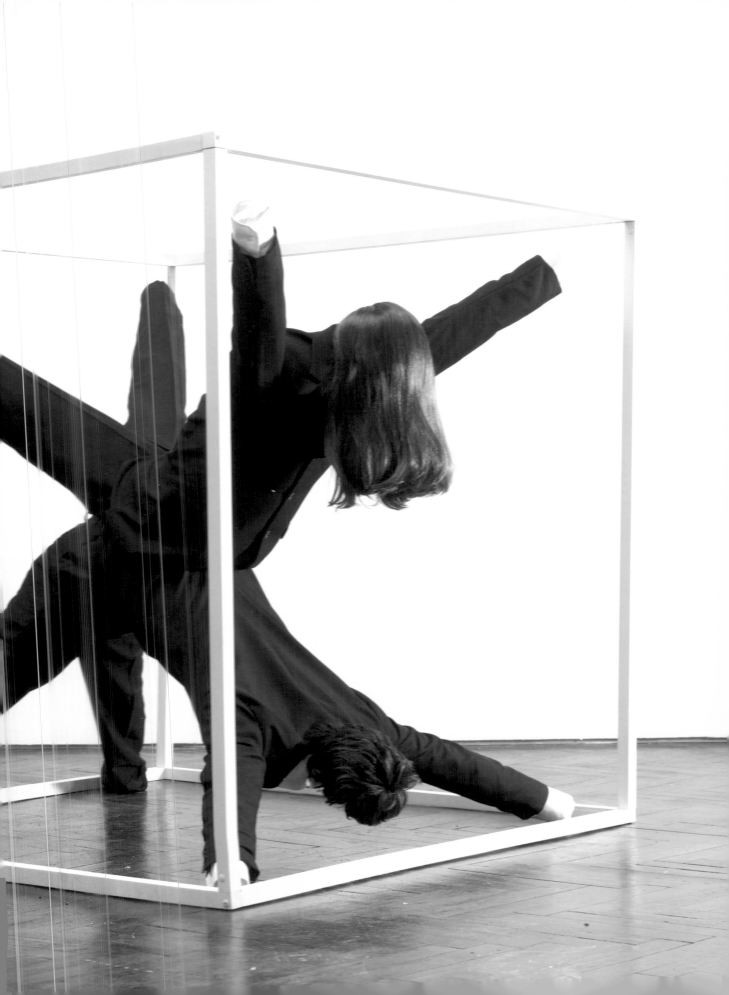

Jo Longhurst
Breed (detail)
C-type prints on aluminium
96, 71 x 2, 38cm
2005

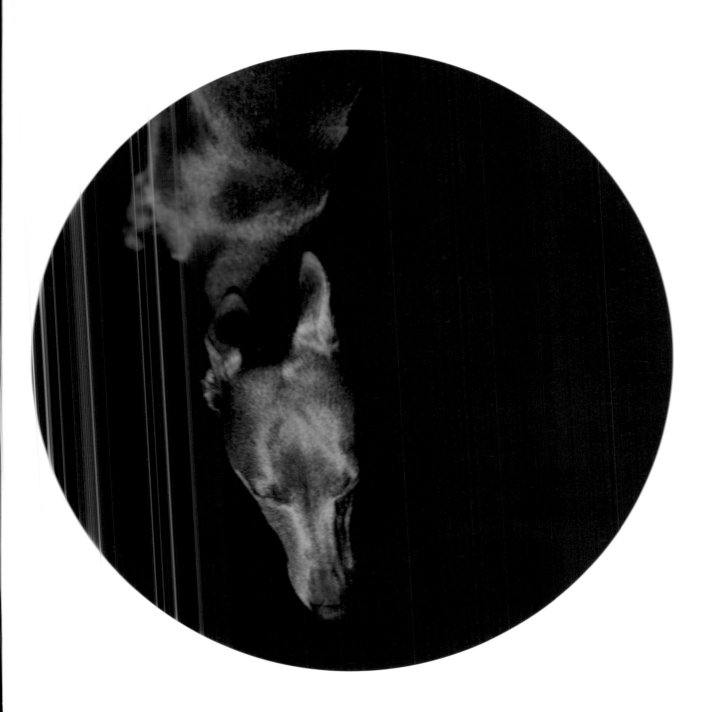

Ellen Macdonald
The Rise and Approach
Oil on canvas
240 x 180cm
2007

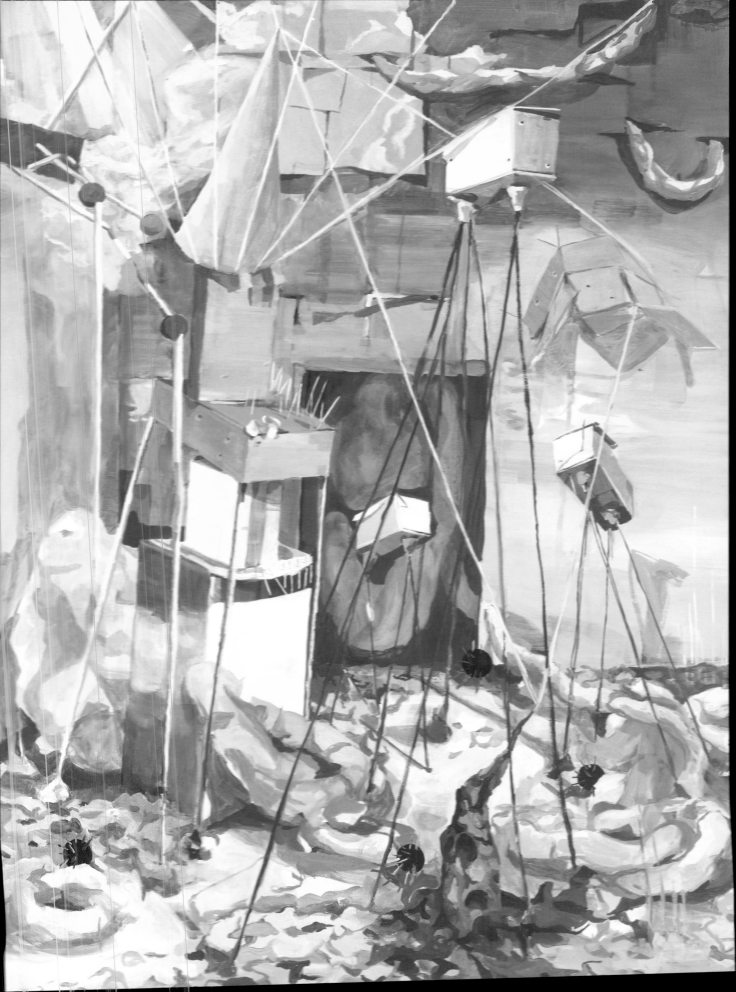

Ellen Macdonald
Idyllic Masquerade
Oil on canvas
198 x 168cm
2007

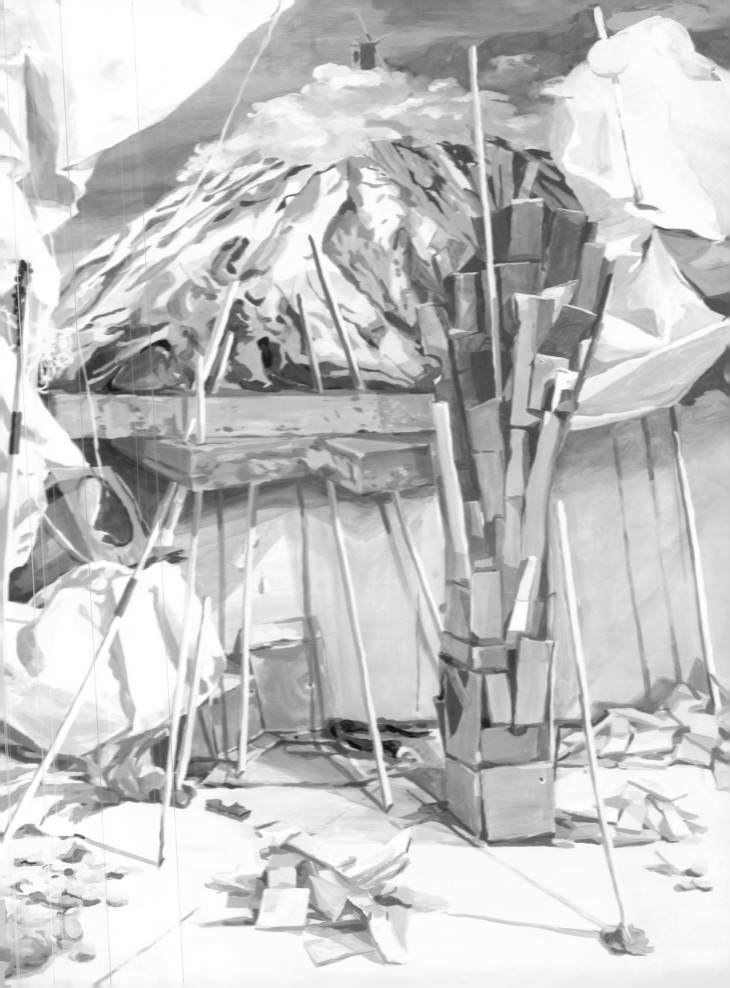

Allison Maletz
Calling
Sound
2002

In the summer of 2002 I was living in a large council flat complex in Finsbury Park, London. Everyday, for hours, a girl would call out a name repeatedly. I'm not sure if she was playing in the courtyard, and calling for her friend or sibling or parent inside, or if she was inside calling out. Although I tried looking for her everyday, out of my window I never saw her. I could not discern the name she called, although sometimes it eerily sounded like my name or my flatmate's name, and we always wanted to respond, but when we tried, there was no one there.

Jane Maughan
Les and the Boys
Gloss laminated ink jet photographic print on Foam-X
150 x 150cm
2008

Colin, Hazel and Tigra
Gloss laminated ink jet photographic print on Foam-X
150 x 150cm
2008

Sarah Michael
Heck Ness
Archival digital print on aluminium
100 x 204cm
2007

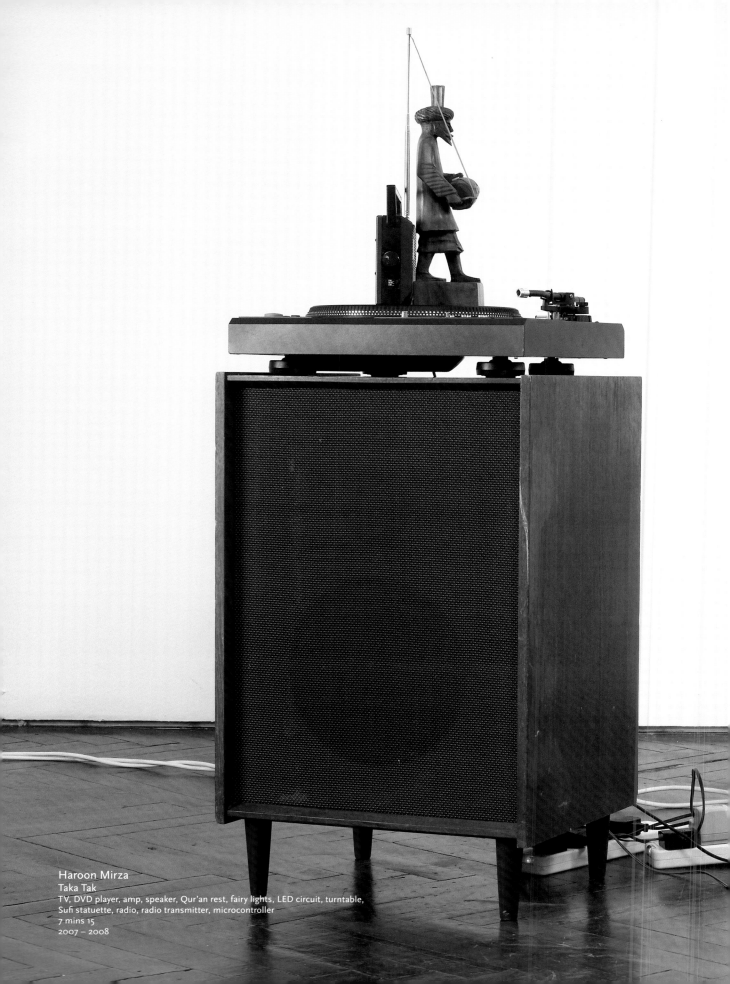

Haroon Mirza
Taka Tak
TV, DVD player, amp, speaker, Qur'an rest, fairy lights, LED circuit, turntable,
Sufi statuette, radio, radio transmitter, microcontroller
7 mins 15
2007 – 2008

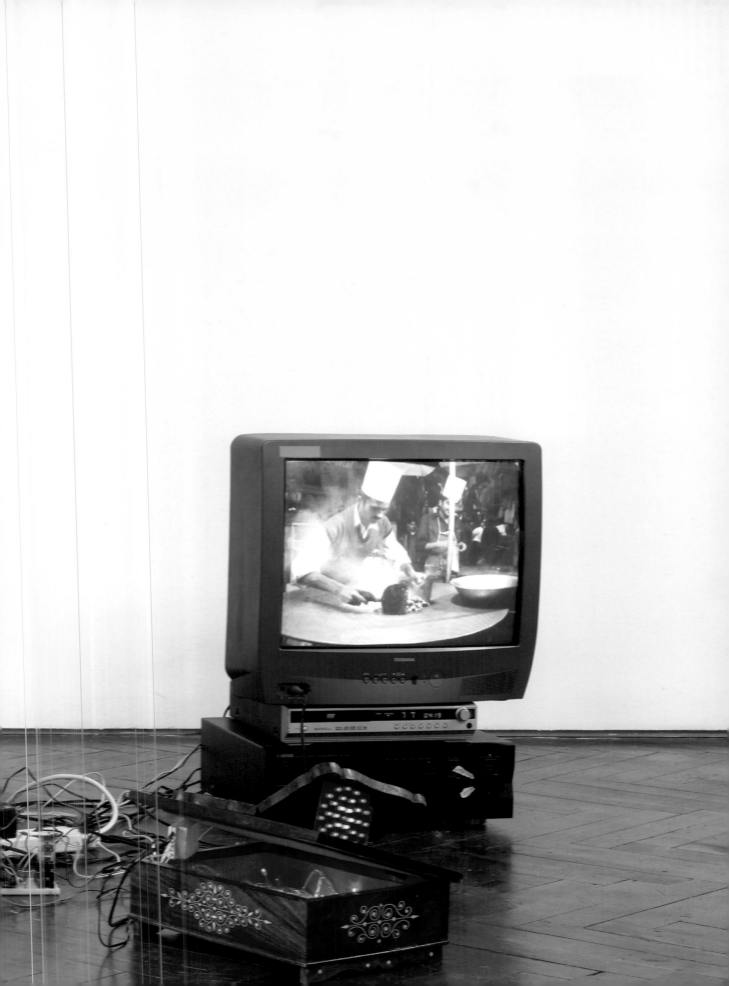

Yoca Muta
Two People
Resin, paint, wigs
30 x 15 x 15cm each
2006

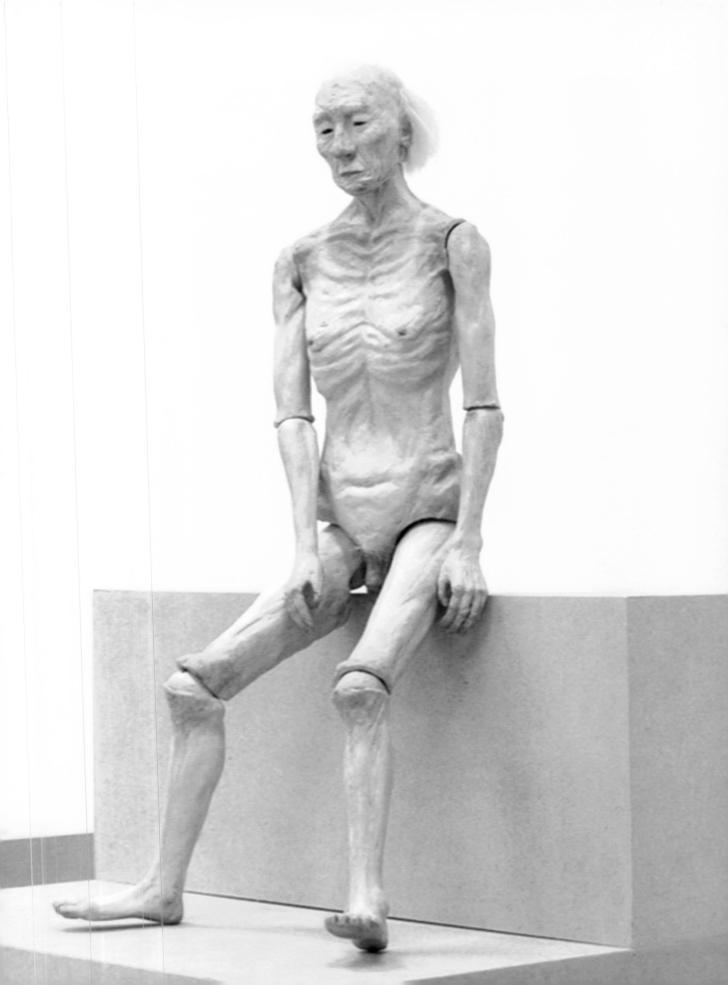

Gemma Nelson
Pornographic Imagination
Indian ink, acrylic and mixed media on canvas
153 x 121cm
2007
In the collection of Alan Jacobs, Jacobs Capital Private Collection

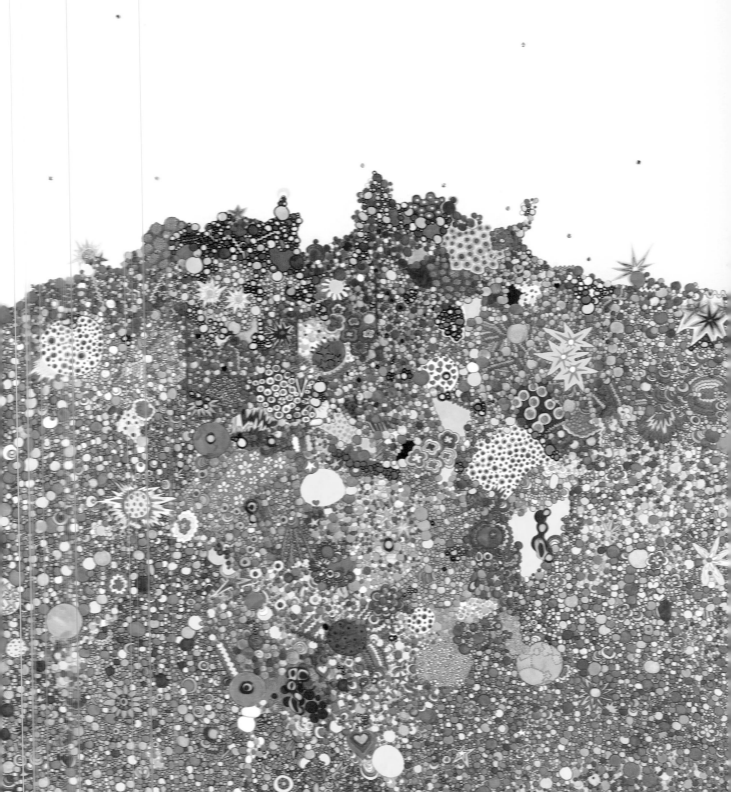

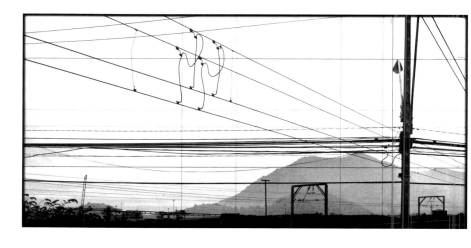

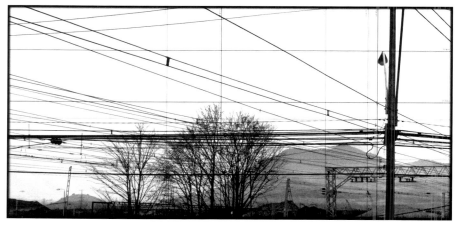

Sachiyo Nishimura
Landscape/Fiction 8
C-Type prints on aluminium
2007 – 2008

Yo Okada
Fire on my deceased grandfather's country house
Oil on canvas
101 x 80cm
2007

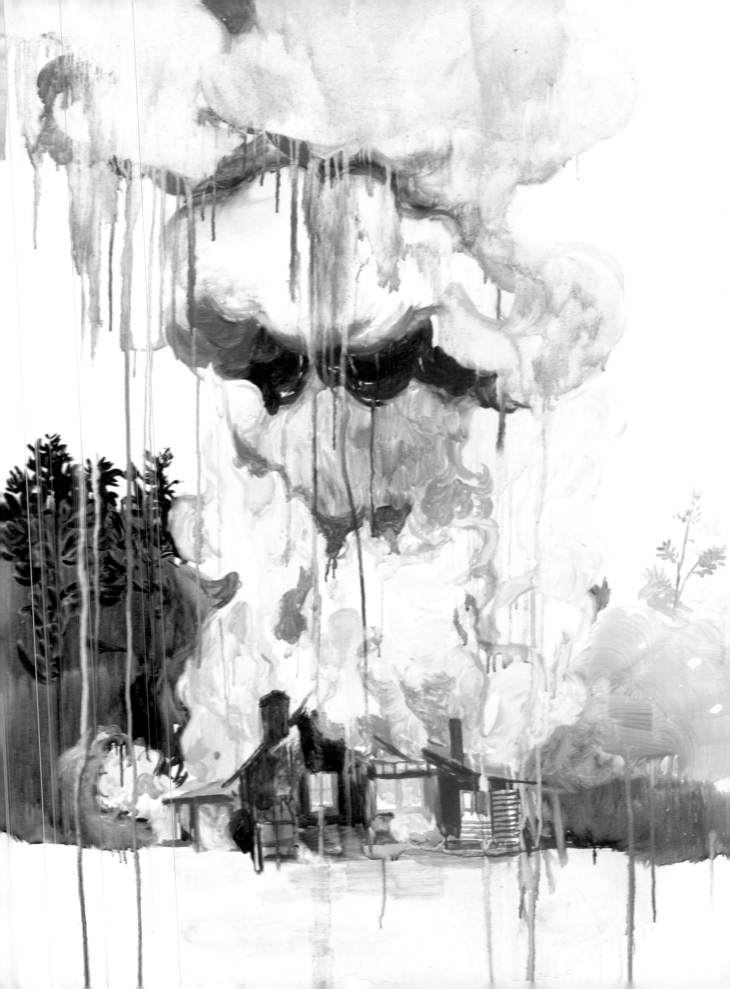

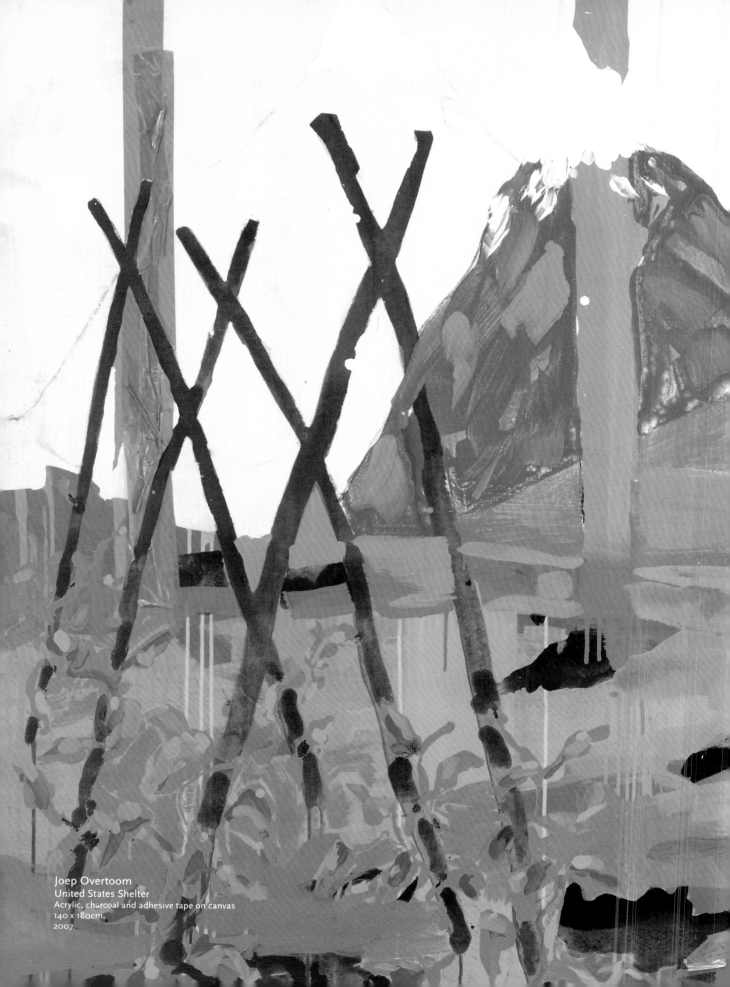

Joep Overtoom
United States Shelter
Acrylic, charcoal and adhesive tape on canvas
140 x 180cm
2007

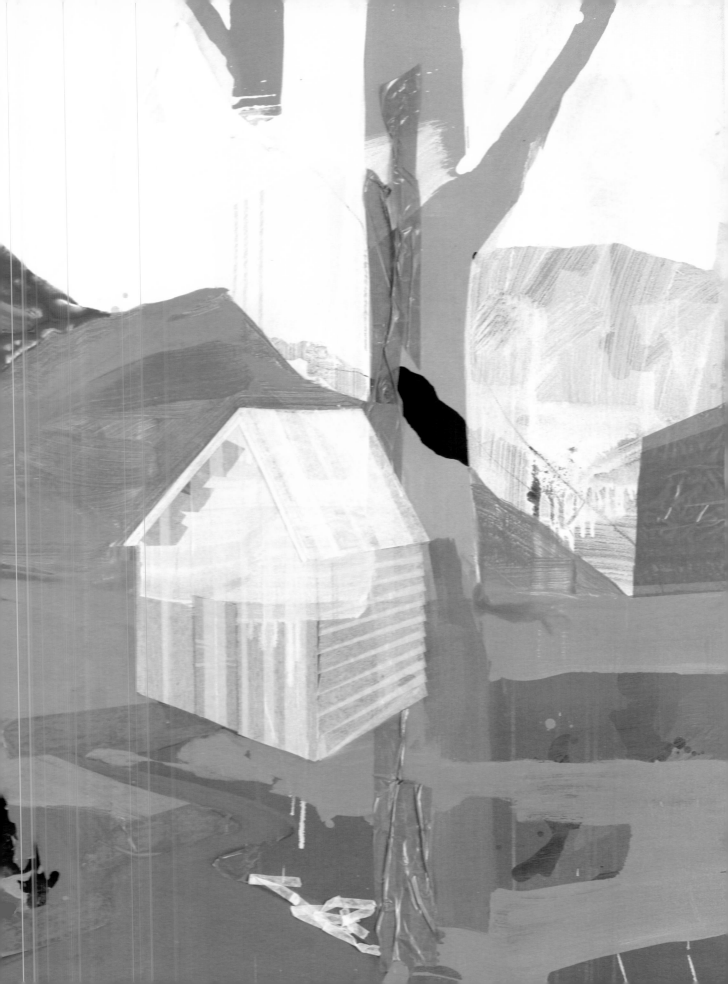

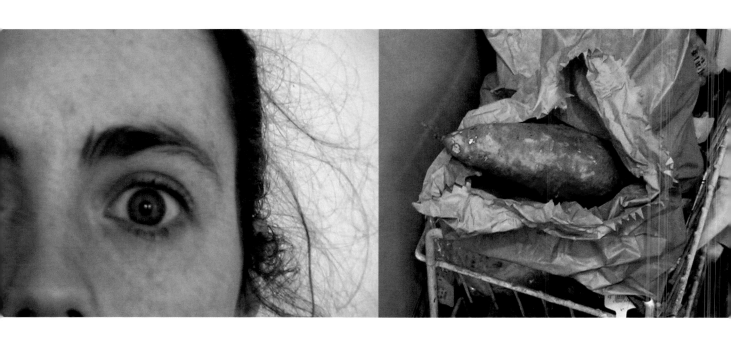

Heather Phillipson
Rebus
DVD video
2 mins 43
2007

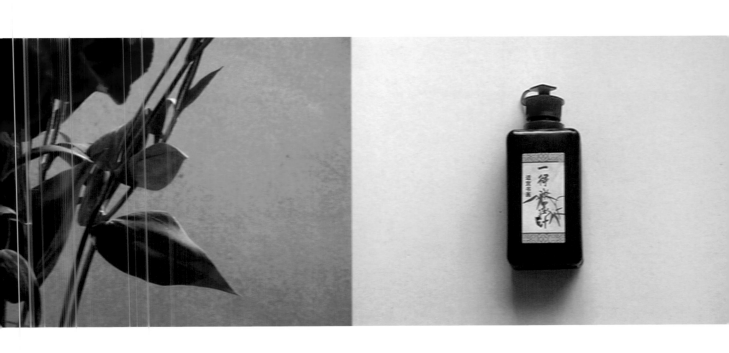

Patricia Pinsker
Davey (production still)
16mm film transferred to DVD
3 mins 11
2008

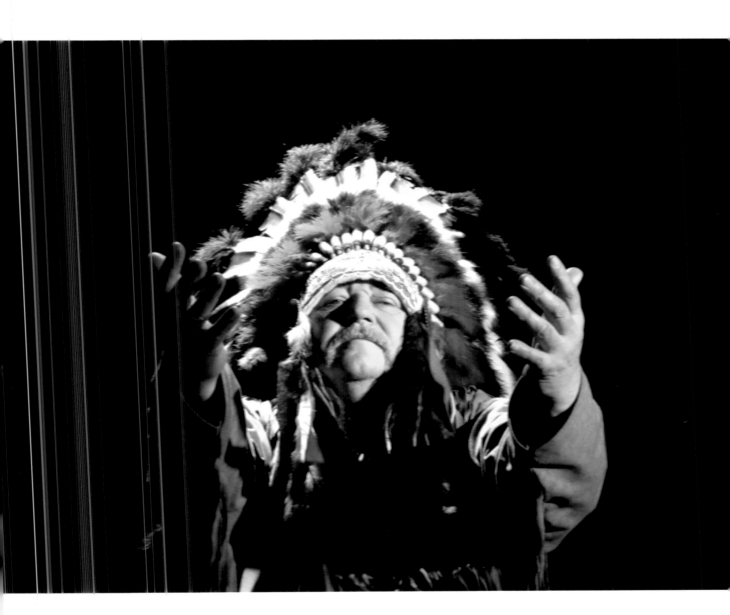

Giles Ripley
Pay Attention
DVD video
6 mins
2007

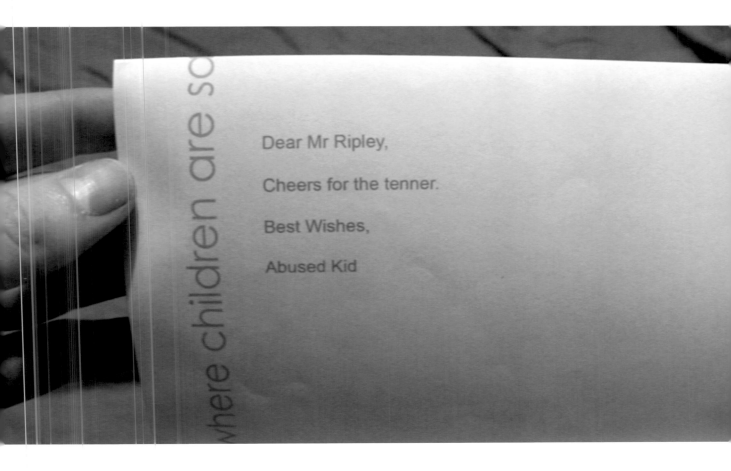

Dear Mr Ripley,

Cheers for the tenner.

Best Wishes,

Abused Kid

Constance Slaughter
Mugs
Oil on canvas
122 x 92cm
2007
Private collection

Rita Soromenho
Lea Bank Walk from the series Peripatetic
Scannogram
Lambda print
55 x 40cm
September 2006 – November 2007

Naomi St Clair-Clarke
The Unconscious Significance of Hair: Queen
Human hair, synthetic hair, stockinette, glue, thread, steel, chicken wire, wadding,
papier mâché
300 x 240 x 270cm
2007

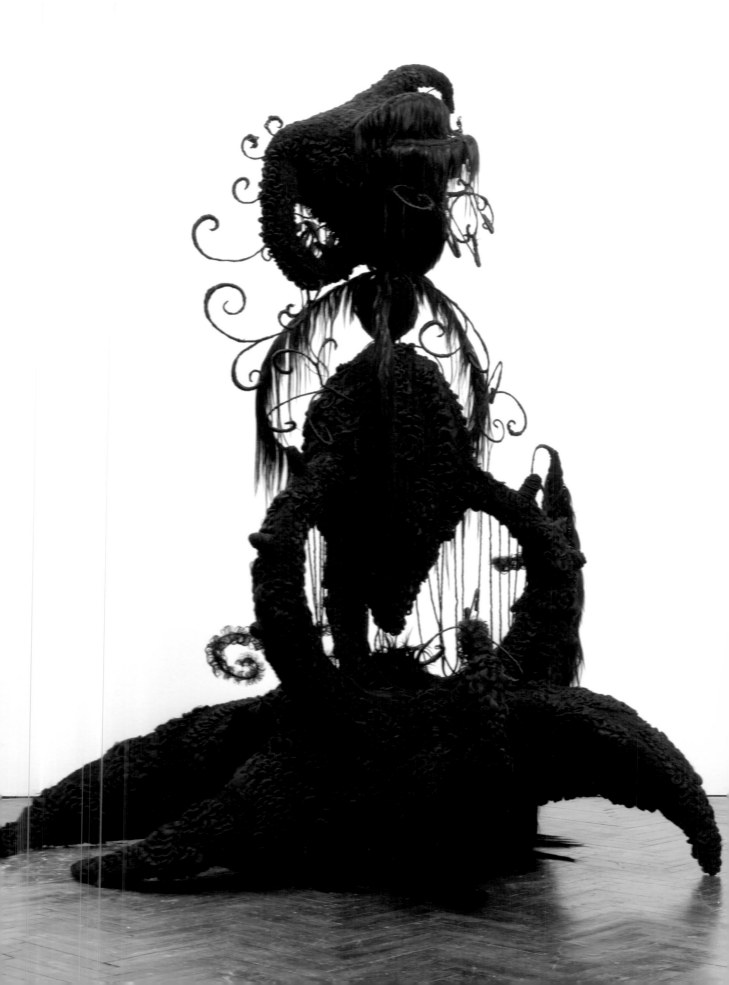

David Stearn
Untitled Interlocking Structure (diamond/146 balloons)
146 latex balloons, oxygen, helium, adhesive dots
137 x 80 x 80cm
Duration 5 hours
2008

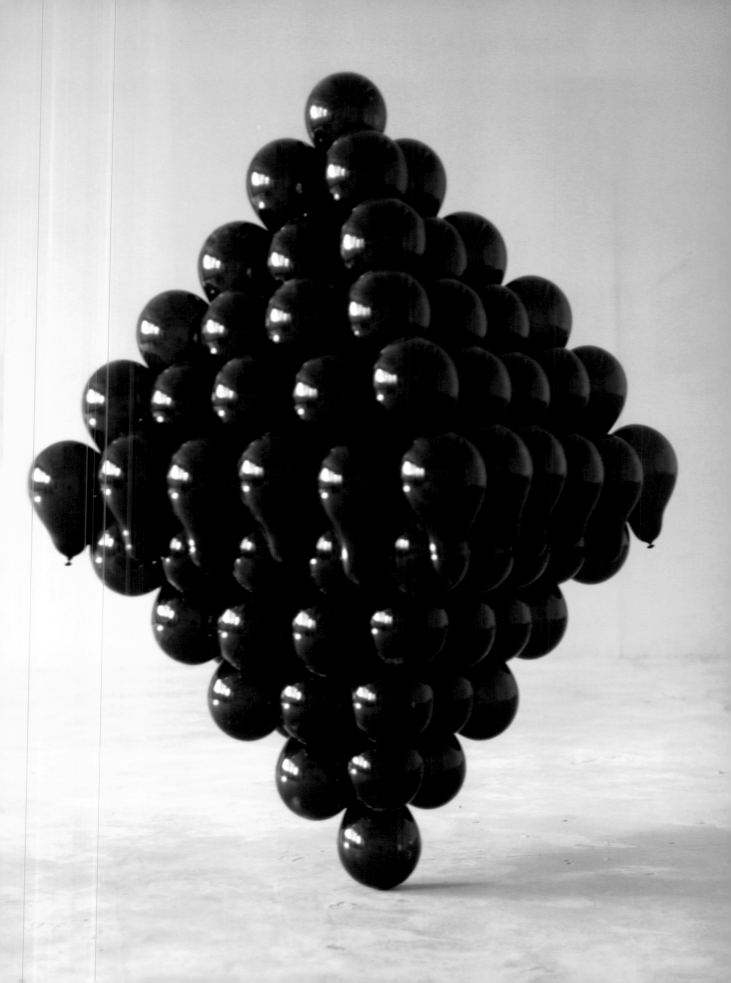

Nicholas Tayler
The Parallels Almanac
Flash website containing digital video, animation and photography
2006 – 2008
www.parallelsalmanac.net

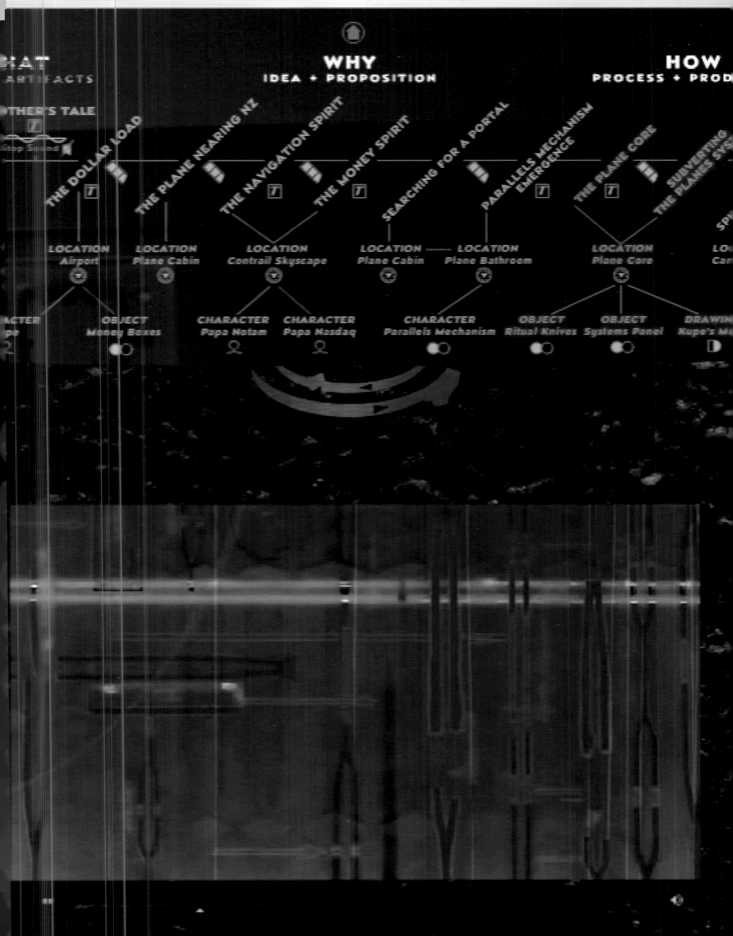

WHY
IDEA + PROPOSITION

HOW
PROCESS + PROD

HAT
ARTIFACTS

THER'S TALE

Stop Sound

THE DOLLAR LOAD

THE PLANE NEARING NZ

THE NAVIGATION SPIRIT

THE MONEY SPIRIT

SEARCHING FOR A PORTAL

PARALLELS MECHANISM
EMERGENCE

THE PLANE CORE

SUBVERTING
THE PLANES SYS

LOCATION
Airport

LOCATION
Plane Cabin

LOCATION
Contrail Skyscape

LOCATION
Plane Cabin

LOCATION
Plane Bathroom

LOCATION
Plane Core

LO
Car

ACTER
pe

OBJECT
Money Boxes

CHARACTER
Papa Notam

CHARACTER
Papa Nasdaq

CHARACTER
Parallels Mechanism

OBJECT
Ritual Knives

OBJECT
Systems Panel

DRAWIN
Kupe's M

Esther Teichmann
Untitled from Stillend Gespiegelt
C-type print
127 x 101cm
2005

David Theobald
Requiem
Computer animation of items scanned using a flatbed scanner
DVD Video
5 mins 27
2007

David Theobald
Greensleeves
Computer animation of original photographs
DVD video
Continuous loop
2007

Jason Underhill
Jessie Lives
DVD video
16 mins 30
2006

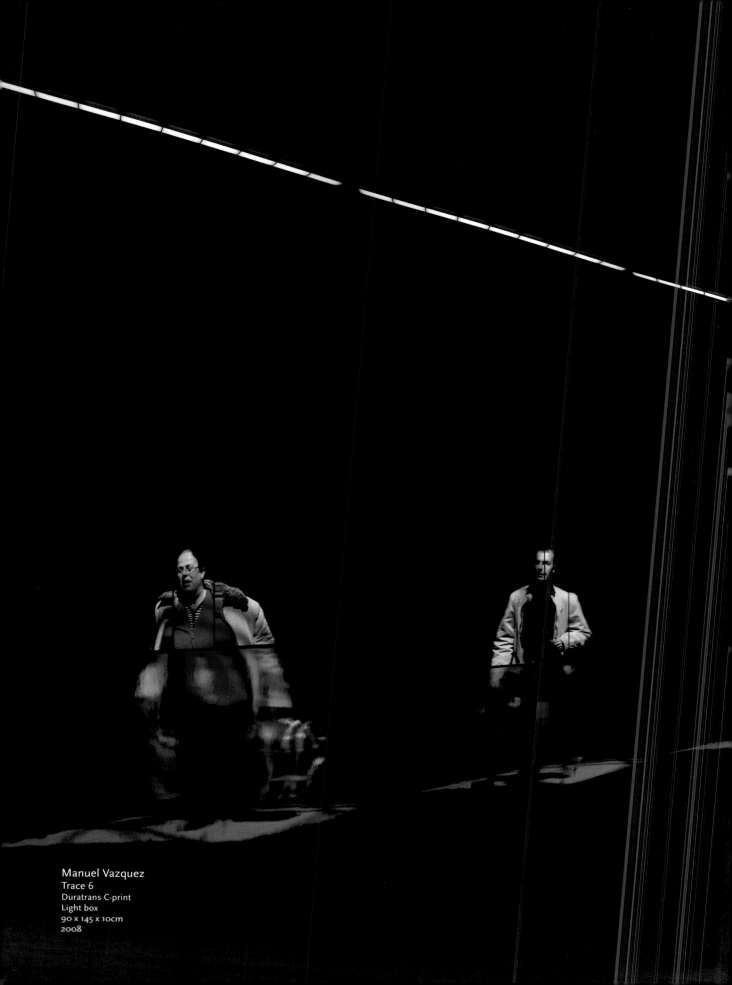

Manuel Vazquez
Trace 6
Duratrans C-print
Light box
90 x 145 x 10cm
2008

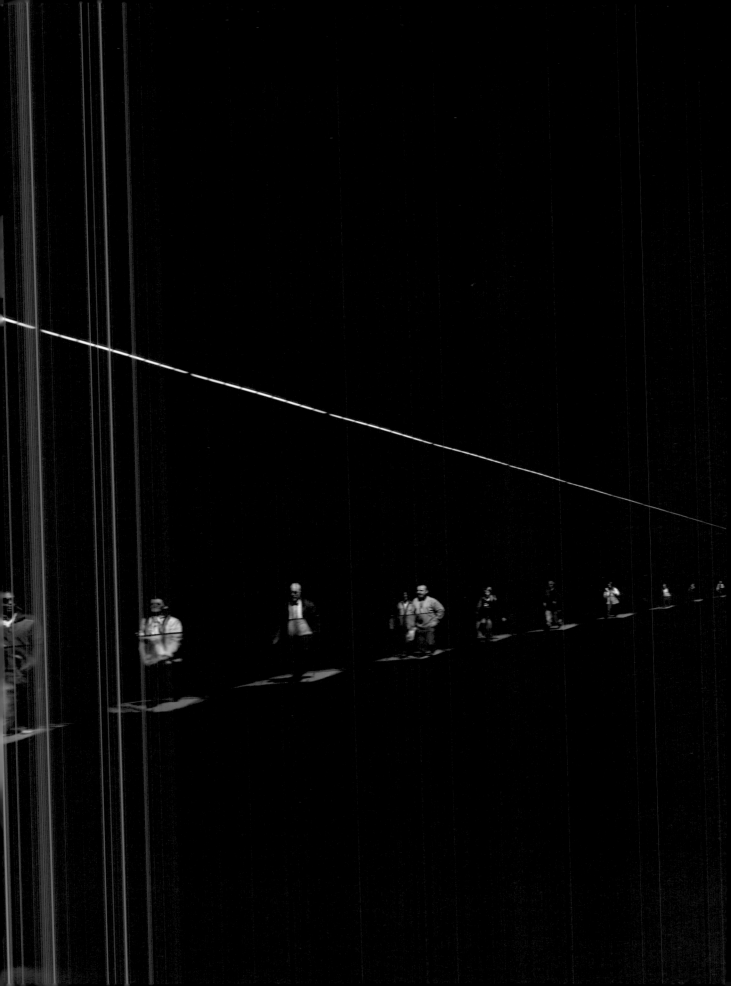

Lara Viana
Mirror
Oil on board
48 x 40cm
2008

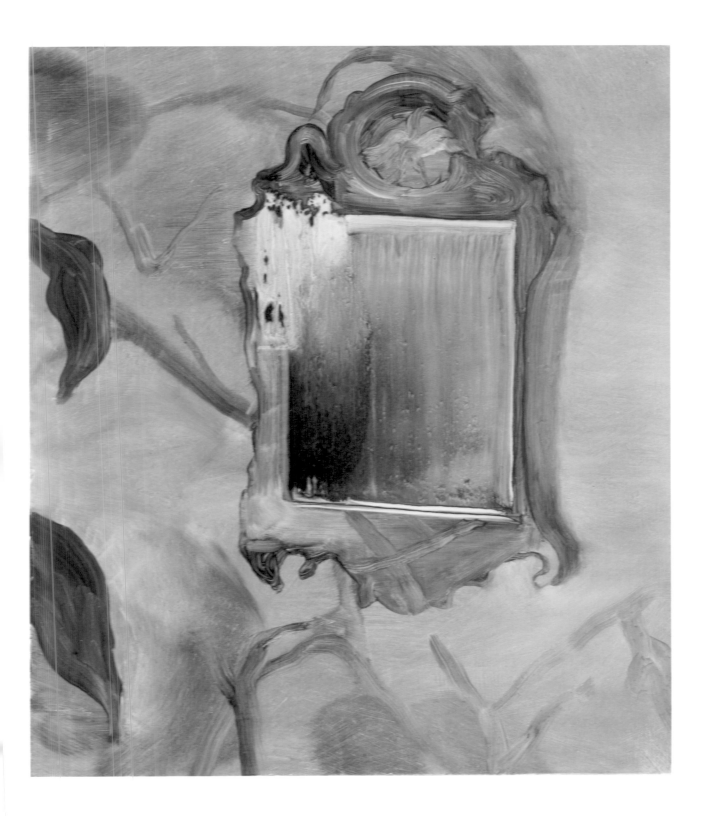

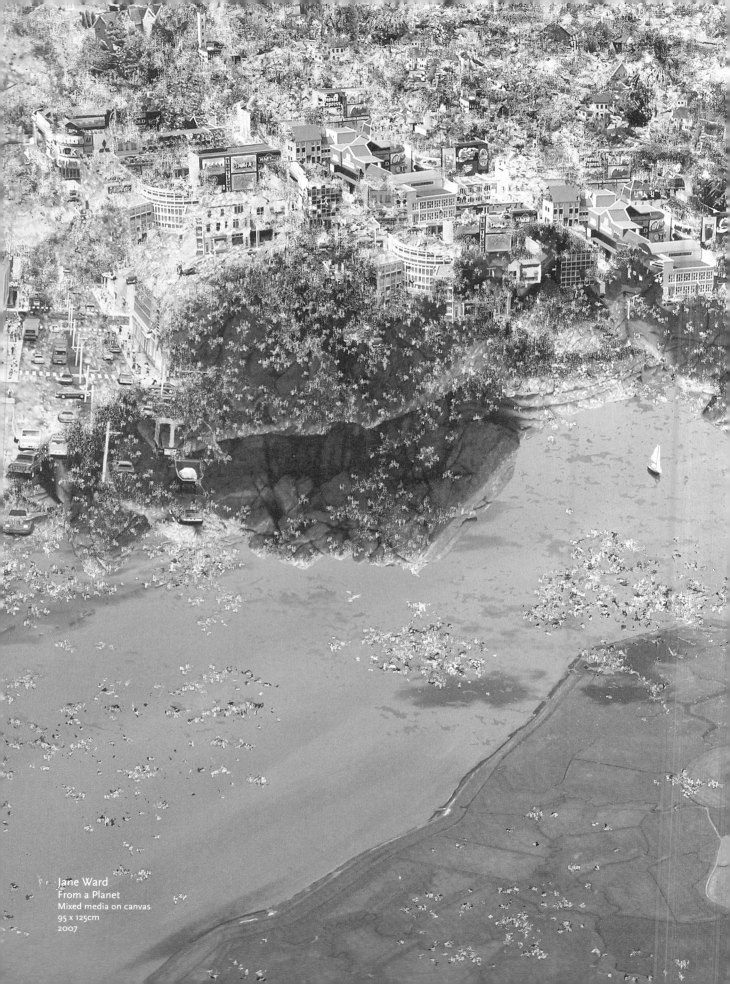

Jane Ward
From a Planet
Mixed media on canvas
95 x 125cm
2007

Anita Wernstrom
Inside
DVD video
8 mins
2008

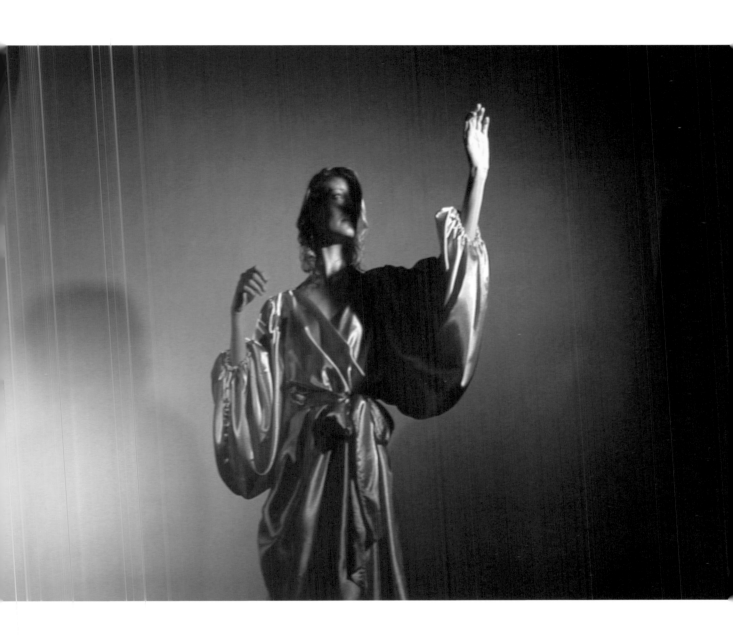

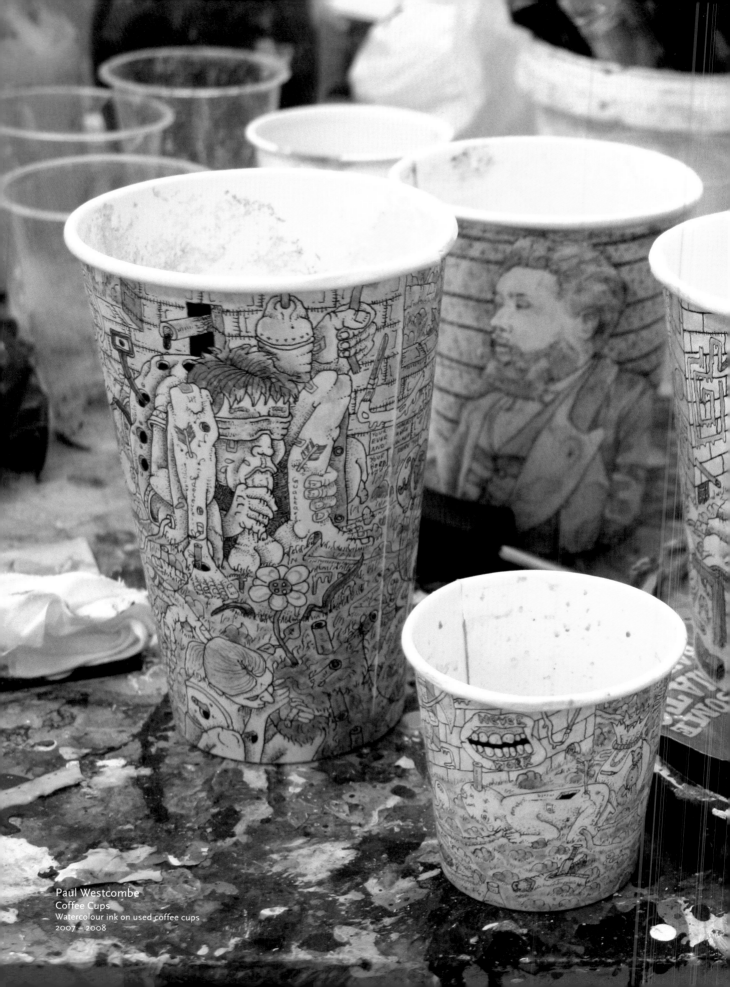

Paul Westcombe
Coffee Cups
Watercolour ink on used coffee cups
2007 – 2008

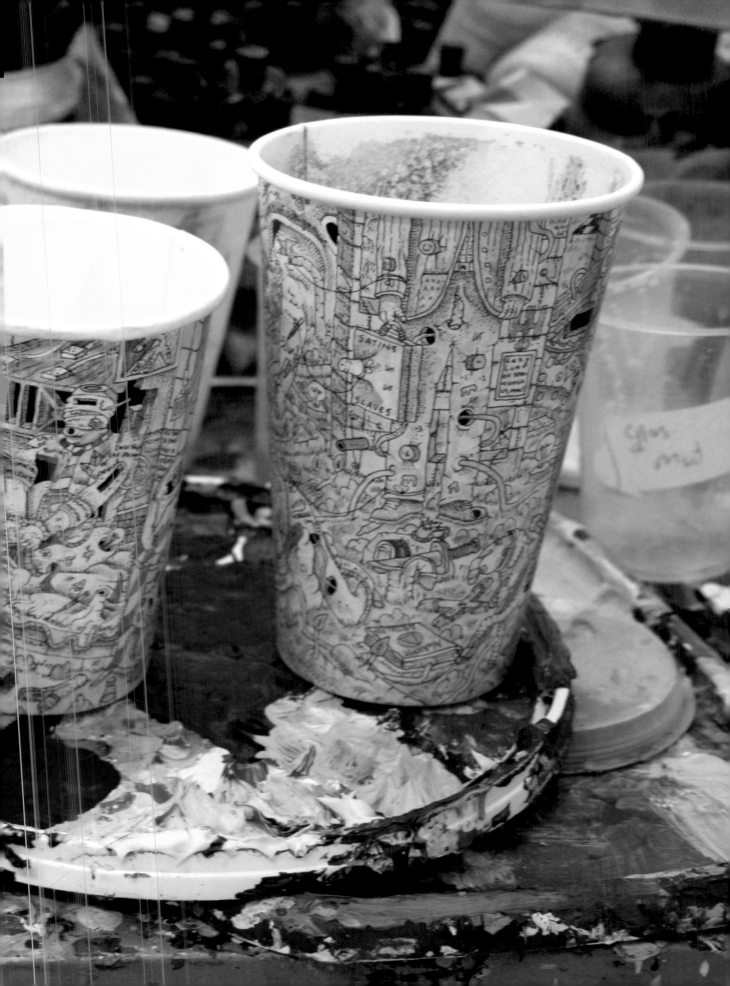

Jeanine Woollard
George
Welding mask, knitting needle, rubble bag, prosthetic hand, bandage, glove, pub
umbrella, workmate, tins of all-day-breakfast, lamps, bungees, mud guard, soap
dispenser, hand towel dispenser, mop, ear protectors, roller and extension pole,
bubble wrap, tape, wire, glue.
200 x 100 x 70cm
2008
Courtesy Gérard Millet

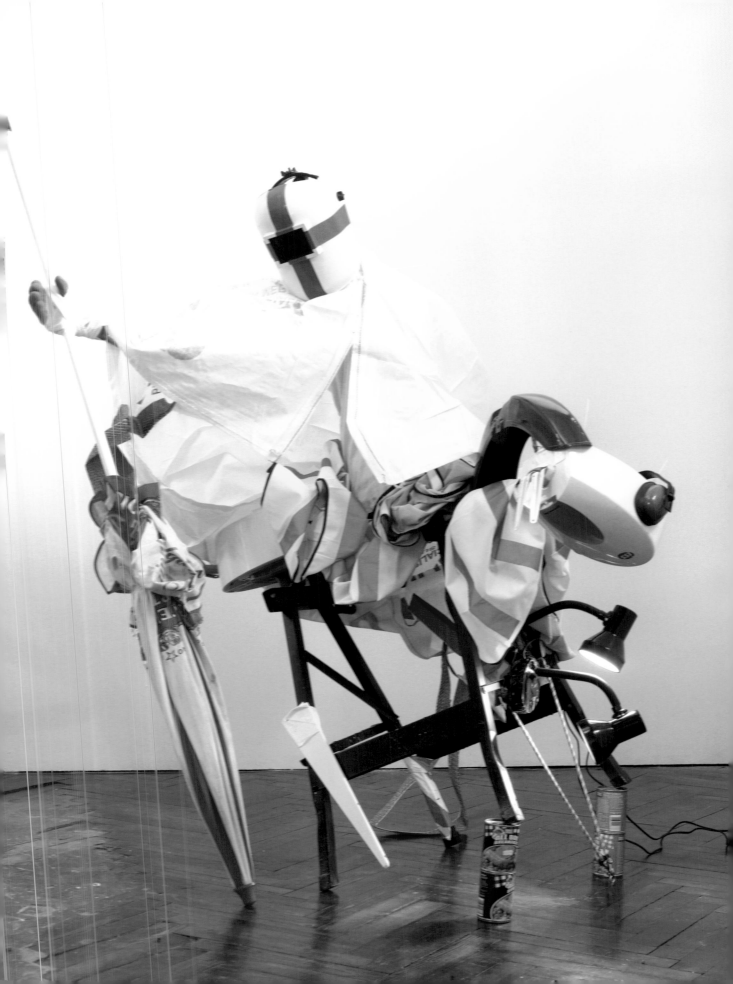

Pio Abad

B 1983 Manila, Philippines
2004–2007 BA (hons) Fine Art, Glasgow School of Art
2006 Erasmus Exchange Programme, Universitat der Künste, Berlin
2002–2004 BA (hons) Fine Art, University of the Philippines, Manila

RECENT EXHIBITIONS
2008 Innermedia Gallery, CCA, Glasgow
2008 The Golden Record, Collective Gallery, Edinburgh
2008 Autarchy, Studio Warehouse Gallery, Glasgow
2008 Patterna, Vegas Gallery, London
2008 A Painting, a Guitar, a Wig and a Wheelie Bag, Kelvinhaugh Arches, Glasgow
2008 ARTfutures, Contemporary Art Society, Bloomberg Space, London
2008 Here Lies Love, Market Gallery, Glasgow
2008 Assembly, Chapter Gallery, Cardiff
2008 Reveal, Edinburgh Printmakers, Edinburgh
2007 Sprezzatura Maze, Studio Warehouse Gallery, Glasgow
2007 Brave Art, Atlantis Gallery, London
2007 Terra Nova IV, Mackintosh Gallery, Glasgow
2007 The Feast, Assembly Gallery, Glasgow

AWARDS & RESIDENCIES
2008 Artist in Residence, Studio Project 10, Market Gallery, Glasgow
2007 Print Commission, Edinburgh Printmakers Co-Publications Programme
2007 Artist in Residence, Springboard Programme, Cove Park
2007 William and Mary Armour Travel Bursary

Adam Ajina

B 1978 Ascot, Berkshire
2005–2007 MA Fine Art, Goldsmiths College, University of London
2003–2004 PG Dip Fine Art, Goldsmiths College, University of London
2000–2003 MBBS, Royal Free Hospital & University College London Medical School
2002 MA Medical & Veterinary Sciences, University of Cambridge
1996–1999 BA (hons) Medical and Veterinary Sciences, University of Cambridge

RECENT EXHIBITIONS
2005 Otherground, The Spitz, London
2005 Sampler, Temporary Contemporary, London

Allsopp & Weir

(Paul Allsopp and Andy Weir)
Formed 2003 London
2005–2007 MA Fine Art, Goldsmiths College, University of London
2002–2003 MA Contemporary Art Theory, Goldsmiths College, University of London

RECENT EXHIBITIONS
2008 Airswap, Manifesta 7, Trentino, Italy
2008 Artquest Residency, Liquidacion Total, Madrid
2008 Behind, Monitor Gallery, Rome
2008 Phase Cancellation, Bogota, Colombia
2007 Permanent Gallery, Brighton
2007 Studio 1.1, London
2007 It's Just Bread, Alma Enterprises, London
2007 Neighbourhood Watch, Nettie Horn, London
2007 Overland, Platform Garanti, Istanbul
2007 The Most Curatorial Biennial of the Universe, Apex Art, New York
2007 Video Art London, Tokyo Wondersite
2006 Arsenal: Artists exploring the Potential of Sound as a Weapon, Alma Enterprises, London
2006 The Sweetest Dream: Unity and Dissonance in Europe, SPACE Gallery, London
2006 Case Study, Beyond the Valley, London; Plymouth Arts Centre, Plymouth
2006 Loop Video Art Festival, Barcelona
2006 CCCB, Blanquerna, Spain
2006 Showroom, Art Basel, with Amberg & Marti Gallery, Zurich
2006 OVL by Rec, ZAIM, Yokohama, Japan
2005 London in Six Easy Steps (Real Estate: Art in a Changing City), ICA, London
2005 Immediate: New Art From the North, Site Gallery, Sheffield
2005 Goethe2 Gallery, Bolzano, Italy
2005 The Artist with Two Brains, St Paul's Church, Birmingham (MOT off-site project)
2005 Video London, Espai Ubu, Barcelona
2005 Videokunstwoche, NBK, Berlin
2005 Beograd Nekad I Sad, National Gallery, Belgrade, Serbia
2004 Trading Places: Migration, Representation and Collaboration in Contemporary Art, Pump House Gallery, London
2004 Exposure, Lux Cinema/Candid Arts, London
2004 Purescreen, Castlefield Gallery, Manchester

Guler Ates

B 1977 Mus, Turkey
2006–2008 MA Printmaking, Royal College of Art, London
2001–2004 BA (hons) Fine Art, Wimbledon College of Art, University of the Arts London

RECENT EXHIBITIONS
2008 Landslide, Café Gallery, London
2007 Ensemble(s)II, Cité Internationale des Arts, Paris
2007 Detroit's 10th International Film Festival, Museum of New Art, Michigan
2006 Visions in the Nunnery, The Nunnery, Bow Arts Trust, London
2005 Solo Projects at Christ Church Spitalfields, London
2005 ID, Crescent Arts, Scarborough
2003 Identity, Guildford Arts, Guildford

AWARDS & RESIDENCIES
2008 Mathews Wrightson Award
2007 The Cité Internationale des Arts

Steve Bishop

B 1983 Toronto, Canada
2006–2008 MA Sculpture, Royal College of Art, London
2003–2006 BA (hons) Fine Art, Kingston University, London

RECENT EXHIBITIONS
2008 The Enigma of William Tell and Other Stories, The Agency, London
2008 Simply Read, Supplement, London
2008 Soul Stripper, Projet Midi, Brussels
2008 Unheimlich, Leeds Metropolitan University Gallery
2007 Bloomberg New Contemporaries, The New Art Gallery Walsall; Club Row, London; Cornerhouse, Manchester
2007 Alternative Possible World, AirSpace Gallery, Stoke on Trent
2007 Salon 07, Seven Seven Contemporary Art, London
2007 S1/Salon Season 4, S1 Artspace, Sheffield
2007 4th Halloween Short Film Festival, ICA, London
2006 Peace Camp, The Brick Lane Gallery, London
2005 Multiples, LOT, Bristol

AWARDS & RESIDENCIES
2007 David Villiers Trust, Travel Grant

Paul Bratt

B 1974 Middlewich, Cheshire
2006–2007 BA (hons) Fine Art, University of
Central Lancashire, Preston

RECENT EXHIBITIONS
2008 The Bluecoat Gallery, Liverpool
2008 Liverpool Film Night, FACT, Liverpool
2007 Prestival, Guildhall, Preston
2007 Visions in the Nunnery, The Nunnery, Bow
Arts Trust, London
2007 Pop-Up 4D, The Venue, Oran Mor,
Glasgow
2006 Inner City Living Exhibition, Preston
2006 Nova Exhibition, Arena Gallery, Liverpool
2005 Howarth Arts Festival, Howarth
2005 Off the Tracks Festival, Derby
2005 Keighley Open Exhibition, Yorkshire
2005 BBC Big Screen, Liverpool City Centre

Stewart Cliff

B 1982 London
2005–2008 PG Dip Fine Art, Royal Academy
Schools, London
2001–2004 BA (hons) Fine Art, Goldsmiths
College, University of London

RECENT EXHIBITIONS
2007 Truck Art presents new work at ART:
CONCEPT, Paris
2006 Premiums, Royal Academy of Arts, London
2006 Truck Art presents new work by…, outside
Alexandre Pollazon Ltd, London

Beth Collar

B 1984 Cambridge
2005–2007 BA (hons) Fine Art Critical Practice,
London Metropolitan University

RECENT EXHIBITIONS
2008 Art Open Örebro, Konsthallen, Örebro,
Sweden
2008 On Time: East Wing Collection, Courtauld
Institute of Art, London
2008 Twelve Steps Down, Shoreditch Town Hall,
London
2007 (Deviant) Art Festival 07, Konsthallen and
Pumphuset Gallery, Trollhättan, Sweden
2006 Give 'em Enough Rope, The Projection
Gallery, Liverpool Biennial of Contemporary Art
2006 Index, Transition Gallery, London
2005 Intercultural Transformations, British
Museum, London; various locations, Karachi,
Pakistan
2005 Trunk Show, The Women's Library, London
2005 I.D.E.A. London Invite the L.C.C.A. to the
ICA, London

Alexia de Ville de Goyet

B 1982 Brussels, Belgium
2007–2008 Film & TV Production, London
College of Communication, University of the
Arts London
2007–2008 PG Dip Fine Art, Byam Shaw School
of Art, University of the Arts London
2006–2007 New Media Time and Space,
Kuvataideakatemia, Helsinki
2003–2007 MA Fine Art Narration, ERG,
Brussels
2002–2005 BA Scenography, Institut Superieur
Saint-Luc, Brussels

RECENT EXHIBITIONS
2008 Jeune Création, Espace d'Exposition La
Vilette, Paris
2008 The Third Bicycle, Lauderdale Gallery,
London
2008 Binocular, Kingsgate Gallery, London
2007 Cartes Flux, Weegee Museum, Espoo,
Finland
2007 The Consequence, Film Festival, Glasgow
2007 Videologia, Film Festival, Volgograd,
Russia
2007 Optica Festival, Gijon, Spain
2007 Raw Festival, New York
2007 Digit Media Film Festival, Tusten Theatre,
New York

AWARDS & RESIDENCIES
2007 Astral Chorus, Best Narrative Film, Digit
Media Film Festival, New York

Joe Doldon

B 1986 Leeds, Yorkshire
2005–2008 BA (hons) Fine Art, Falmouth
College of Arts

RECENT EXHIBITIONS
2008 Fleet, Trinity Buoy Wharf, London
2007 Shipton Mill, Malmesbury
2007 Hitchens, Falmouth
2007 Level 2, The Poly, Falmouth

Jeremy Evans

B 1963 London
2002–2007 BA (hons) Fine Art, Chelsea College
of Art and Design, University of the Arts London

RECENT EXHIBITIONS
2008 Home, Blackheath, London
2007 Return It (two), My Life in Art, London
2007 Letting Go, Waterloo Gallery, London
2007 Material Intelligence, Trinity Buoy Wharf/
Keith Talent Gallery, London
2006 Exhibition, Brent Artists Resource, London
2006 4, Waterloo Gallery, London
2005 Future Film, Camden Arts Centre, London
2005 Squash, Gallery 47, London
2005 Reflection, Curzon Cinema, London

Anwen Handmer

B 1977 Perth, Australia
2006–2008 MA Fine Art, Slade School of Fine
Art, University College London
2001–2003 BA (hons) Fine Art, Curtin
University, Perth

RECENT EXHIBITIONS
2008 The Body Project, Slade Research Centre,
London
2007 Uncanned, The Foreign Press Association,
London
2005 HomeTurf, Fremantle Arts Centre,
Fremantle, Australia
2004 The White Show, The Church Gallery,
Perth
2004 Goddard de Fiddes Gallery, Perth
2004 Hatched PICA, Perth Cultural Centre
2004 Figured Out, The Church Gallery,
Claremont, Australia
2004 Waiting to Hear a Pin Drop, Margaret River
Art Galleries, Australia
2003 New Works/New Faces, Perth Galleries,
Perth
2002 Life in Paradise, Margaret River Art
Galleries, Australia

AWARDS & RESIDENCIES
2007 Christmas in July, Alsop Architects Studio
Residency Programme, London
2003 Studio Excellence Award, Faculty of Built
Environment, Art and Design, Curtin University

Chris Hanlon

B 1978 Poole, Dorset
2006–2008 MA Painting, Royal College of Art, London
1999–2002 BA (hons) Fine Art, Brighton University

RECENT EXHIBITIONS
2009 Chris Hanlon, Domobaal, London
2008 Impulse Project Booth, Chris Hanlon and Miho Sato, Pulse, Miami
2008 Anticipation, Ultralounge, Selfridges, London
2008 Bank of America, London
2007 The Ten They Couldn't Hang, Hockney Gallery, Royal College of Art, London

Gabriel Hartley

B 1981 London
2005–2008 PG Dip Fine Art, Royal Academy Schools, London
2002–2005 BA (hons) Fine Art, Chelsea College of Art and Design, University of the Arts London

RECENT EXHIBITIONS
2008 John Moores Painting Prize, Walker Art Gallery, Liverpool
2008 Group Show, Parade Space, London
2008 Peles Collection, Peles, London
2007 Bloomberg New Contemporaries, The New Art Gallery, Walsall; Club Row, London; Cornerhouse, Manchester
2007 Premiums, Royal Academy of Arts, London
2007 Straight Edge, La Viande, London
2007 Influx, Nolia's Gallery, London
2007 Touch, Chelsea Future Space, London
2005 Harvest, Long and Ryle, London

Gerd Hasler

B 1979 Austria
2005–2007 MA Photography, Royal College of Art, London
2006 Residency at the Kyoto City University of Arts, Japan
2003–2005 Philosophy and Art History, University of Vienna
2000–2003 BA (hons) Photography, University of Westminster, London
1999–2000 RSA Advanced Diploma in Photography and Audio Visual Studies, Filton College, Bristol

RECENT EXHIBITIONS
2008 Nearly Nothing, Viewfinder Photography Gallery, London
2008 European Night – European Photographic Identities, Les Rencontres d'Arles, France
2007 Landscape Photography, Sadler's Wells, London
2007 Casa Décor Loft Exhibition, London
2007 Summer Show, Hoopers Gallery, London
2007 The Great Exhibition, Royal College of Art, London
2006 15th Foreign Student Exhibition, Kyoto Arts Centre, Japan

AWARDS & RESIDENCIES
2007 Hoopers Gallery Award
2007 Davis Langdon Award
2006 Kyoto Residency Scholarship, Royal College of Art
2006 Flash Forward: Emerging Photographers from Canada, the UK and USA
2006 Critique of the Alps Exchange, Lausanne, Switzerland

Neil Hedger

B 1970 London
2007–2008 MA Fine Art, Goldsmiths College, University of London
1989–1993 BA (hons) Fine Art, Duncan of Jordanstone College of Art and Design, Dundee
1994–2007 Sculptor for the film industry, television and advertising

FILM CREDITS
Troy
Phantom of the Opera
Charlie and the Chocolate Factory
The Da Vinci Code
The Golden Compass

Tyler Bright Hilton

B 1979 Toronto, Canada
2008 MA Fine Art, Chelsea College of Art and Design, University of the Arts London
2004–2007 BA (hons) Fine Art, Ontario College of Art and Design, Canada

RECENT EXHIBITIONS
2008 Condensation, Decima Gallery, London
2008 Slideshow, XPACE, Toronto
2008 Decade, Katharine Mulherin Contemporary Art Projects, Toronto
2008 Work'n it, Headbones Gallery, Toronto
2007 Aqua Art Miami, Katharine Mulherin Contemporary Art Projects, Miami
2007 dead cats dead rats, Swapna Tamhane's Unit 309, Toronto
2007 Drawing, Glenhyrst Art Gallery, Brantford, Canada
2007 Insomnia, Redhead Gallery, Toronto
2007 Do it at the Gladstone, Gladstone Hotel, Toronto
2007 Minmei Madelynne Pryor Went into the Dryer, Katharine Mulherin Slideshow, Toronto
2007 The Figure, Leighton Art Gallery, Calgary
2007 A Climate for Change, Propeller Gallery, Toronto
2006 Art to Ease Crappy Conversation, Loop Gallery, Toronto
2006 Cycles Perfecta, Katharine Mulherin Slideshow, Toronto
2006 New Work, Gallerie Bertosinni, Toronto

AWARDS & RESIDENCIES
2008 International Multidisciplinary Art Residency, Loznica Cultural Centre, Trisc, Serbia and Montenegro

Sam Holden

B 1978 Bristol
2007 MA Photography, London College of
Communication, University of the Arts London
2000–2003 BA (hons) Editorial Photography,
University of Brighton

RECENT EXHIBITIONS
2008 The Mirror Stage, Independent Museum of
Contemporary Art (NeMe), Limassol, Cyprus
2008 Fresh Faced and Wild Eyed, The
Photographers' Gallery, London
2008 Shorts, Norwich Arts Centre, Norfolk
2007 Surveillance, South Hill Park Arts Centre,
Bracknell
2007 Throes, Victoria Court Interiors,
Nottingham
2007 Photography for Beginners, London College
of Communication
2005 Photographers – Part One, The
Independent Newspaper Saturday Magazine
2004 Reactions, OKI Gallery, Brooklyn, New
York
2003 Click, The Bridge Gallery, London
2002 Surface Noise, Escola Mansana, Barcelona
2000 Interior, Derelict building, New North
Road, Exeter

AWARDS & RESIDENCIES
2002 Kentmere Black & White Photography
Prize

COLLECTIONS
National Portrait Gallery, London
Private Collections

Alex Hudson

B 1976 Croydon
2006–2007 MA Fine Art, Wimbledon College of
Art, University of the Arts London
1997–2000 BA (hons) Fine Art, Kingston
University, London

RECENT EXHIBITIONS
2008 The Invention of Solitude 11, Leicester City
Art Gallery and off-site spaces
2007 Annual Open, Café Gallery Projects,
London
2007 Start Your Collection!, Contemporary Art
Projects, London
2006 Grotto, Studio 1.1, London
2006 The Invention of Solitude 1, The Nunnery,
Bow Arts Trust, London
2005 Odyssey, The Study Gallery, Dorset
2005 Common Ground, Annual Open
Exhibition, Artsway, Hampshire
2005 Invisible, Artworks Studio, Poole Quay,
Dorset
2004 View, Annual Open Exhibition, Artsway,
Hampshire
2004 Fridge Collaborative Project, The Study
Gallery, Dorset
2003 Wild Wood, Stone, London

Peter Joslyn

B 1973 Wheathampstead, Hertfordshire
2006–2008 MA Fine Art, Goldsmiths College,
University of London
1998–2001 BA (hons) Fine Art, London
Guildhall University

RECENT EXHIBITIONS
2008 Meisterwerke der Menschheit 2,
Tanzschule, Munich, Germany
2008 Freedom Centre, Hales Gallery, London
2008 Bass Diffusion Model, Fieldgate Gallery,
London
2008 Jargon of Landscape, Wallis Gallery,
London
2008 Is the World Flat?, Arti et Amicitiae,
Amsterdam
2008 Fall in Theatre 2, Takecourage Gallery,
London
2007 Year 07, County Hall, London
2007 Lobby, Hales Gallery, London
2007 Fall in Theatre, V22, London
2005 You're Welcome, House Gallery, London
2004 You're Welcome to Come, Vyner Street,
London
2002 One Plus Two Equals, 14 Wharf Road,
London
2001 Fresh Art, Business Design Centre, London

Emmanuel Kazi Kakai

B 1977 Kakamega, Kenya
2005–2008 BA (hons) Digital Arts, Thames
Valley University, London

RECENT EXHIBITIONS
2008 Electric Canvas, Watermans Arts Centre,
Brentford, London

Eva Kalpadaki

B 1974 Heraklio, Crete
2003–2007 PhD Arts and Communication,
University College for the Creative Arts,
Maidstone
1998–2002 BA (hons) Photography,
Technological Educational Institute, Athens
1993–1997 Diploma in Physics, University of
Patras, Greece

RECENT EXHIBITIONS
2008 Potential Space for Abstraction,
TheSpace@Acumen, Brighton
2007 Empty Space, George Rodger Gallery,
University College for the Creative Arts,
Maidstone
2005 Fotoebnefsi, The Hellenic Centre, London
2003 Internal Reflections, Ano Archanes, Crete
2003 Internal Reflections, Photosynkyria 2003,
Thessaloniki
2003 LOOKOUT, Athens First Aesthetic Public
Intervention of Unpredictable Size
2003 Photosiginonoume (Photocommunicating),
an exhibition of the competition routes organised
by the Greek Ministry of Transportation
2000 Archanes – Light, Ano Archanes, Crete
2001 New Colour, Athens Photographic Centre
2001 New Glance, 8 West, Athens
1998 & 1999 Patras, A Town in 13 Stories,
Photographic Centre of Thessaloniki; National
Bank, Patras, Greece
1997 Applied and Art Photography, University of
Patras Photographic Club Exhibition, Old Public
Hospital of Patras, Greece

Katharina Kiebacher

B 1974 Fressing, Germany
2007–2009 MFA Glasgow School of Art, Glasgow
2003–2006 Diplom KD, Folkwangschule, Essen

RECENT EXHIBITIONS
2008 Video Screening, CCA, Glasgow
2008 RSA Student Exhibition, Royal Scottish Academy, Edinburgh
2008 At the Beginning there is Darkness, Goethe Institute, Glasgow
2007 Musterung, Ballhaus, Düsseldorf
2007 Auktion 2007 im NAK, Neuer Aachener Kunstverein, Aachen
2006 Mögliche Orte, stadt.bau.raum, Gelsenkirchen
2006 Public Folder #2 – Fussball Cuisine Digitale, Museumsquartier, Vienna, Gallerie Ariess, Essen
2006 Fahrzeuge, Raum für Kunst und Musik, Cologne
2006 Auktion 2006 im NAK, Neuer Aachener Kunstverein, Aachen
2005 Privatkontacte, Staedtische Galerie Villingen-Schwenningen
2005 Privatkontacte, Internationale Fototage, Mannheim
2005 Alles aus Versehen, Amtsgericht Langenfeld
2004 Katastrophen, Kunst Klub Köln, Cologne
2004 Warm Up, Staedtische Galerie Wolfsburg

Rinat Kotler

B 1975 Ramat Gan, Israel
2006–2008 MA Fine Art, Slade School of Fine Art, University College London
2000–2003 BED Photography and Art, Hamidrasha School of Art, Beit Berl College, Israel

RECENT EXHIBITIONS & SCREENINGS
2008 Visits to (Some)where, BWA Gallery, Poland
2008 European Media Art Festival, Germany
2008 Calypso, Sala Rekalde, Spain
2007 Trace, Slade Research Centre, Woburn Square, London
2006 Tel Aviv Artists Studios (with Hillel Roman), Israel
2006 Still and Sparkling, METIS_NL Gallery, Amsterdam
2006 Pixels of Reality, PSWAR, Amsterdam
2006 Body Imprints, Tivon Gallery, Israel
2005 Emerging Artist Award, Israeli Ministry of Education and Culture, Tel Aviv Museum of Art
2005 Janco Dada Museum Ein Hod, Israel
2005 X-territory, Rehovot Art Gallery, Israel
2004 Absent Place, Noga Gallery of Contemporary Art, Israel
2004 Window Project, Noga Gallery of Contemporary Art, Israel
2003 Hamidrasha Gallery, Israel
2003 Kabri Gallery for Israeli Art, Israel
2003 In-House, Young Jewish & Arab Artists Joint Project, Umm El-Fahm Art Gallery, Israel

Raakhee Lakhtaria

B 1980 London
2007–2008 PG Cert Photography, Central Saint Martins College of Art and Design, University of the Arts London

RECENT EXHIBITIONS
2008 Photography Show, Corbet Place, Old Truman Brewery, London
2008 Photography Show, Arts Club, Mayfair, London

Andrew Larkin

B 1985 Chatham, Kent
2007–2009 MA Painting, Royal College of Art, London
2004–2007 BA (hons) Fine Art, University College for the Creative Arts, Canterbury
2006 Exchange, AUT, Auckland, New Zealand

RECENT EXHIBITIONS
2009 Ghost Tank, Blyth Gallery, Imperial College, London
2008 Credit Crunch, Battersea, London
2008 Bank of America, Canary Wharf, London
2008 Caption, Hockney Gallery, Royal College of Art, London
2007 RCA Secret, Royal College of Art, London

Ian Law

B 1984 Isle of Wight
2007–2009 MA Painting, Royal College of Art, London
2003–2006 BA (hons) Fine Art, Camberwell College of Arts, University of the Arts London

RECENT EXHIBITIONS
2008 Darbyshire Award, Stroud

littlewhitehead

Craig Little B 1980 Glasgow
Blake Whitehead B 1985 Lanark, Scotland
2003–2007 BA (hons) Visual Communication (Illustration), Glasgow School of Art

RECENT EXHIBITIONS
2008 Nothing Ever Happens Here, Studio Warehouse, Glasgow
2008 It was Gone, Project Slogan, Aberdeen
2007 D&AD New Blood, London

AWARDS & RESIDENCIES
2007 Chairman's Medal, Glasgow School of Art

Joseph Long

B 1985 London
2008–2010 MA Painting, Royal College of Art, London
2005–2008 BA (hons) Painting, Wimbledon College of Art, University of the Arts London

RECENT EXHIBITIONS
2007 Rietveld Pavilion, Amsterdam
2007 PA KT, Amsterdam

Jo Longhurst

B 1962 Chelmsford, Essex
2001–2008 PhD Fine Art, Royal College of Art, London
1980–1984 BA (hons) Russian with Politics, University of Leeds

RECENT EXHIBITIONS
2008 The Animal Gaze, Unit2, London Metropolitan University and touring
2008 Pavilion Commissions, National Media Museum, Bradford
2008 The Refusal (Part III) Pavilion, Leeds
2008 Anticipation, Ultralounge, Selfridges, London
2008 Royal College of Art Summer Show, Hoopers Gallery, London
2008 The Refusal, Museum Folkwang, Essen
2008 Phantasma, Ballhaus/Nordpark, Düsseldorf
2008 Parade, Shunt Vaults, London
2007 To the Dogs, Presentation House Gallery, Vancouver
2007 Anticipation, One One One, London
2006 The Photographed Animal/Useful, Cute and Collected, Museum Folkwang, Essen
2006 Twelve Dogs, Twelve Bitches, Discovery Award Show, Les Rencontres d'Arles, France
2006 Descent, MAC, Birmingham
2006 Future Face, National Museum of Natural Science, Taipei, Taiwan
2006 Too Dark in the Park, Café Gallery Projects, London
2005 Summer Exhibition, Royal Academy of Arts, London
2005 Breed, Studio 1.1, London
2004 Future Face, Wellcome Gallery, Science Museum, London
2004 Weeds, Hiscox Artprojects, London
2003 Ausländer, Dahl Gallery of Contemporary Art, Lucerne, Switzerland

Ellen Macdonald

B 1983 Stirling, Scotland
2003–2007 BA (hons) Painting, Glasgow School of Art

RECENT EXHIBITIONS
2008 Neue Grunstr. 20, Berlin
2007 Royal Scottish Academy, Edinburgh
2007 Newbury Gallery, Glasgow
2006 Panopticon Gallery, Glasgow

AWARDS & RESIDENCIES
2007 Armour Prize, Glasgow School of Art
2007 Landscape Award, Royal Scottish Academy
2003 Drawing Prize, Leith School of Art

Allison Maletz

B 1981 California, USA
2007–2009 MA Fine Art, Slade School of Fine Art, University College London
1999–2003 BFA Photography, Rhode Island School of Design, Providence, USA
2001–2002 RISD European Honours Program (EHP), Rome

RECENT EXHIBITIONS
2008 Curator, The Body Project, Slade Research Centre, London
2008 21st Century Watercolour, Bankside Gallery, Royal Watercolour Society, London
2006 Scope, Christopher Henry Gallery, Miami
2006 RISD Biennial, New York
2006, Exit Art, New York
2005 Circumnavigate, Capsule Gallery, New York
2005 Show & Sell, Milk Gallery, New York
2004 In a Conversation, Capsule Gallery, New York
2004 Forbidden Vision, Angel Oransenz Foundation, New York
2003 Night of One Thousand Drawings, Artist Space, New York
2003 New York International Film & Video Festival, New York
2003 Here, Red Eye Gallery, Providence
2002 Heaven, Catalyst Arts, Pawtucket
2002 RISD Photography, Woods-Gerry Gallery, Providence
2002 Four Years of Fingerprints, Temple University Gallery, Rome
2001 Sketchbook, Piazza Cenci, Rome
2001 A Cardboard Suitcase Full of Ghosts, Galeria Medium, Bratislava

Jane Maughan

B 1974 Taplow, Berkshire
2005–2008 MA Fine Art, Sir John Cass School of Art, London Metropolitan University
2001–2004 BA (hons) Fine Art, Sir John Cass School of Art, London Metropolitan University

RECENT EXHIBITIONS
2008 Summer Exhibition, Royal Academy of Arts, London
2008 Go Elephants!, The Forum Trust, Norwich
2007 Mental Image, Project Ability, Glasgow
2006 Oncology, Metropolitan Pavilion, New York
2006 Re-Generation, White Space, County Hall, London
2006 Oncology, Royal College of Art, London
2004 Beauty Queens, Women's Library, London
2002 Artist's Book, London Metropolitan University

Sarah Michael

B 1979 London
2004–2007 PG Dip Fine Art, Royal Academy Schools, London
2001–2004 BA (hons) Fine Art and History of Art, Goldsmiths College, University of London

RECENT EXHIBITIONS
2008 ARTfutures, Contemporary Art Society, Bloomberg Space, London
2008 Photo 50, London Art Fair
2007 Identity, Parco Culturale La Serra, Turin
2007 Direct Approaches, The Leaf Gallery, Harrow
2006 The Hole in the Brambles, Start Contemporary Gallery, Brighton
2006 Theatrium Pitticorum, Nolia's Gallery, London
2006 Young Artists Poland and Britain, Wisnyvz Castle, Poland
2005 Perforations, Bubblegum, London
2004 Yesvember, House Gallery, London
2004 Recent Graduates, Affordable Art Fair, London
2004 Bloomberg New Contemporaries, Coach Shed, Liverpool Biennial; The Curve, Barbican, London
2004 Coolbrands, Truman Brewery, London

AWARDS & RESIDENCIES
Landseer Award
Dunoyer de Segonzac Award
The Hugh Merrill Dissertation Award

COLLECTIONS
Ernst and Young
IVI Investors
Mizuho International PLC

Haroon Mirza

B 1977 London

2007 MA Fine Art. Chelsea College of Art and Design. University of the Arts London
2004–2006 MA Design: Critical Theory and Practice. Goldsmiths College. University of London
1999–2002 BA (hons) Fine Art. Winchester School of Art
2001 Exchange. BFA Fine Art. School of the Art Institute of Chicago

RECENT EXHIBITIONS

2008 Cabaret Futura. Cell Project Space. London
2008 More Pricks Than Kicks. Generator Projects. Dundee
2007 Noise Reduction: Off. Dreizehnzwei. Vienna
2007 Future Map. Arts Gallery. University of the Arts London
2007 Group show curated by VVORK. Galerie West. The Hague
2007 How We May Be. Late at Tate. Tate Britain. London
2007 Working Things Out. Spike Island. Bristol
2007 A Church. a Courtroom & then Goodbye. SoePlex. Nashville. Tennessee
2007 Tearfully. Grey Area. Brighton
2007 The Air is Wet with Sound. Rekord. Oslo
2007 Sound-Space. South Hill Park Arts Centre. Bracknell
2006 Pixelpops_06. C2C Gallery. Prague
2006 REGELEI. WUK. Kunsthalle Exnergasse. Vienna
2005 Synthetic Reality. Bury St Edmunds Art Gallery. Suffolk
2005 Accept All Cookies. Dreizehnzwei. Vienna
2005 Never Finished Always Ready. Spitalfields. London
2005 Nationwide Mercury Art Prize. Air Gallery. London
2005 Redundancy. Aspex. Portsmouth
2003 Synthetic Pleasures. Dreizehnzwei. Vienna
2003 Show#1. 4wests. London
2003 A4 vs. Letter. RK Burt. London and 1R Gallery. Chicago
2003 Who is John Galt. Fizz Gallery. Chicago
2001 Two Blokes et Le Minette. Art Institute of Chicago

AWARDS & RESIDENCIES

2007 National College of Arts. Lahore
2006 Lynda Brockbank Scholarship. Chelsea College of Art and Design
2005 Nationwide Mercury Art Prize shortlist

Yoca Muta

B 1981 Tokyo. Japan

2002–2003 BA Painting. Tokyo Zokei University
2006–2008 BA Fine Art. Goldsmiths College. University of London

RECENT EXHIBITIONS

2007 Photo Exchange. Goldsmiths College. University of London
2004 Kyu-Hosobuchi Building Show. Tokyo
2003 Ikachi-Hiroba. Tokyo Zokei University

SCHOLARSHIPS

2008 Nicholas and Andrei Tooth Travelling Scholarship

Gemma Nelson

B 1984 West Yorkshire

2003–2007 BA (hons) Fine Art. Slade School of Fine Art. University College London

RECENT EXHIBITIONS

2009 Art/Form. Arcadas Do Parque. Estoril. Portugal
2008 Affordable Art Fair. Battersea Park. London
2008 Gemma Nelson & Matt Franks. Laure Genillard Gallery. London
2007 Rising Stars. Coombe Gallery. Devon
2007 4 New Sensations. Saatchi Gallery and Channel 4. Truman Brewery. London
2007 Gissings. Finsbury Circus. London
2007 Nationwide Mercury Art Prize. The Hospital Gallery. London
2007 Art>Enterprise. James Hockey & Foyer Gallery

COLLECTIONS

2008 Veronique Rolland Private Collection
2008 John Private Collection
2008 Jacobs Capital Private Collection. Bond Street. London
2007 Charlie Bosworth Private Collection

Sachiyo Nishimura

B 1978 Santiago. Chile

2007–2008 MA Fine Art. Central Saint Martins College of Art and Design. University of the Arts London
1996–2001 BA Fine Art. Universidad Católica de Chile

RECENT EXHIBITIONS

2008 This Constant Cracking of the Surface. Oxo Tower Wharf. London
2008 Signes d'existence. Museo Nacional de Bellas Artes. Buenos Aires. Argentina
2007 Signes d'existence. Museo de Arte Contemporáneo. Santiago de Chile
2007 Cityscapes and Fictions. Galeria AMS. Santiago de Chile
2006 Landscape/Panorama: Out of Scale. Galeria Animal. Santiago de Chile
2006 Composition Schemes. Galeria AFA. Santiago de Chile
2006 Transit and Transitions. Museo de Artes Visuales. Santiago de Chile

AWARDS & RESIDENCIES

2005 First Prize. Literarte III. Galeria Artespacio. Santiago de Chile
2003 First Prize. XXV Arte Joven. Universidad de Valparaiso. Chile

Yo Okada

B 1974. Kanagawa. Japan

2005–2007 MA Fine Art. Goldsmiths College. University of London
1997–1999 MA Painting. Musashino Art University. Tokyo
1993–1997 BA Painting. Musashino Art University. Tokyo

RECENT EXHIBITIONS

2008 Blitzkrieg Bop. Man&Eve. London
2007 Allotment. Seven Seven Contemporary Art. London
2007 Pages. Notice Gallery. London
2007 Jungle Juice. EM Gallery. Seoul
2007 Black Powder + White Party. Kyunghee University Museum of Contemporary Art. Seoul
2006 Wight Biennial: Anxiety of Influence. New Wight Gallery UCLA. Los Angeles
2005 Summer Show. Kamakura Gallery. Kanagawa. Japan
2004 VOCA (The Vision of Contemporary Art. Visual Arts Award). Ueno Royal Museum. Tokyo

Joep Overtoom

B 1981 Berkel en Rodenrijs, Holland
2006–2008 MA Fine Art, Goldsmiths College, University of London
2001–2005 BA (hons) Fine Art, Royal Academy of Art, The Hague

RECENT EXHIBITIONS

2008 Is the World Flat?, Arti et Amicitiae, Amsterdam
2008 Lodging, Bearspace, London
2008 Schil/ders, DCR, The Hague
2007 Black Powder + White Party, Kyunghee University Museum of Contemporary Art, Seoul
2007 Jungle Juice, EM Gallery, Seoul
2007 Annus Mirabilis, Galerie Smits, Amsterdam
2006 Lousy Cream, Galerie Smits, Amsterdam
2006 Spacequake, MAMA Showroom for Media and Moving Art, Rotterdam
2006 Orde en chaos, Kunstambassade/ Groothandelsgebouw, Rotterdam
2006 Contemporary Dutch Painting, Loods 6, Amsterdam
2006 Parallax, Kaus Australis, Rotterdam
2005 Distinctive Edges, Centrum Beeldende Kunst, Rotterdam
2005 Royal Pickles, Erasmus Universiteit, Rotterdam

Heather Phillipson

B 1978 London
2004–2008 PhD Fine Art, Middlesex University, London
2003–2004 PG Cert Drawing, Central Saint Martins College of Art and Design, University of the Arts London
1998–2001 BA (hons) Art and Aesthetics, University of Wales Institute, Cardiff

RECENT EXHIBITIONS

2008 Expo, Sonic Arts Network, Brighton
2008 Write Side of the Brain, The Miller, London
2007 Fingerlakes Environmental Film Festival, New York
2007 Salon, S1 Artspace, Sheffield
2006 Mandlehanded, The Tram Depot, London
2006 Projector/Max 5, The Café Gallery, London
2006 Visions in the Nunnery, The Nunnery, Bow Arts Trust, London
2006 700IS Reindeerland, Culture Centre of Fljótsdalshérad, Egilsstadir, Iceland, touring to Sequences Festival, Reykjavik, Iceland; Monkeytown Art Centre, New York; VAIA 2006, Valencia, Spain; Skalvijos Kino, Vilnius, Lithuania; Folly Art Centre, Lancaster; Volatile Works, Montreal
2006 Bad Drawing, University Galleries on Sycamore, Cincinnati
2005 Directions, Lethaby Gallery, London

AWARDS & RESIDENCIES

2008–2009 Artist in Residence, London College of Fashion
2008 Eric Gregory Poetry Award

Patricia Pinsker

B 1975 Hong Kong
2006–2008 MA Photography, Royal College of Art, London
1998–2002 BA (hons) Fine Art, Slade School of Fine Art, University College London

RECENT EXHIBITIONS & SCREENINGS

2008 Passerby, Guestroom, London
2007 Projektor, Café Gallery Projects, London
2007 Failure, Photomonth, Krakow, Poland
2003 Independent Exposure-Microcinema Screening Tour, 111 Minna Gallery, San Francisco; Oakland Opera Theatre, Oakland; Miami Beach Cinematheque; Axiom Theatre, Houston; New Space, Portland; Lundabio (Puffin Cinema), Reykjavik
2003 2nd Annual Detroit International Video Festival, Museum of New Art, Detroit
2002 Contemplation Room, Group Show, Overgaden, Copenhagen

Giles Ripley

B 1986 Huddersfield, Yorkshire
2005–2008 BA (hons) Fine Art, Chelsea College of Art and Design, University of the Arts London

RECENT EXHIBITIONS

2008 Best in Show, John Jones Project Space, London
2008 Ex, Foyer, Leeds College of Art and Design
2008 Departures, The White Nave, Dover
2008 Anticipation, Ultralounge, Selfridges, London
2008 XHIBIT, The Hub Gallery, London
2008 Sharp Shorts, The Hub Gallery, London
2008 Vault, Shoreditch Town Hall, London
2008 MC Motors, Millers Avenue, London
2007 Some Quiet Pursuit, The House Gallery, London

Constance Slaughter

B 1964 Paris
2004–2007 BA (hons) Fine Art, Central Saint Martins College of Art and Design, University of the Arts London

RECENT EXHIBITIONS

2008 Unstill Life, The Apartment Gallery, London
2008 Affordable Art Fair, Cynthia Corbett Gallery, London
2008 FORM Art and Design Fair, Olympia with the Cynthia Corbett Gallery, London
2007 CHASE Exhibition, Royal College of Art, London
2007 Cynthia Corbett Gallery, City Inn Westminster, London
2007 SLICK Art Fair, Paris
2007 Summer Show: Top 25 London Art Graduates, SaLon Gallery, London
2005 Six artists: Multimedia Show, Chelsea Old Town Hall, London
2003 CHASE Exhibition, Royal College of Art, London

Rita Soromenho

B 1977 Lisbon, Portugal
2005-2007 M.A Photography, London College of
Communication, University of the Arts London
2002 Photography II, Ar Co Centre for Arts and
Visual Communication, Lisbon
1995-1999 B.A (hons) Media and Film Studies,
FCSH, Universidade Nova de Lisboa, Portugal

RECENT EXHIBITIONS
2008 Anticipation, Ultralounge, Selfridges,
London
2008 FORM Art and Design Fair, Olympia,
London
2008 Through the Lenses, RWA Open
Photography Exhibition, Royal West of England
Academy, Bristol
2007 Foundations, Roof Unit and [SPACE]
Studios, London
2007 Mysteries, Secrets, Illusions, Kaunas
Picture Gallery, Lithuania
2006 Distortions: Challenging the Real Through
Photography, La Viande Gallery, London
2005 Intimacy 'Human People', Photomonth,
Campbell Works, London
2005 Definition 5, Praxis Nr6, London

Naomi St Clair-Clarke

B 1973 London
2004-2007 BA (hons) Sculpture, Camberwell
College of Art, University of the Arts London

RECENT EXHIBITIONS
2008 Chutney Preserves 2, The Rot Sets in,
Camberwell Arts Week, Camberwell Green,
London
2007 Iota, Cell Project Space, London
2007 I Love Peckham, Shop Windows, Ace Hair
& Beauty, London
2006 Simon Ould and Mark McGowan Present
Chicken, The Guy Hilton Gallery, London
2005 The Power of OHM, Area 10, Peckham,
London

AWARDS & RESIDENCIES
2008 Scottish Sculpture Workshop, Lumsden,
Aberdeenshire
2004 Paul Edwards Award for Outstanding
Achievement in the Creative Arts

David Stearn

B 1986 Harlow, Essex
2005-2008 BA (hons) Fine Art, Byam Shaw
School of Art, University of the Arts London

Nicholas Tayler

B 1982 Invercargill, New Zealand
2007-2008 MArch, Bartlett School of
Architecture, London
2005-2007 Diploma in Architecture, Bartlett
School of Architecture, London
2004-2005 PG Cert Photography, Central Saint
Martins College of Art and Design, University of
the Arts London
2000-2003 BA Architecture, Edinburgh College
of Art

RECENT EXHIBITIONS & SCREENINGS
2008 South by Southwest Film Festival, Austin,
Texas
2007 The Parallels Almanac, ICA, London
2007 Kupe and the Whale, Café de Paris, London
2007 The Parallels Almanac, Bartlett Summer
Show, Slade School of Fine Art, London
2006 Underwater Exploration, Bartlett Summer
Show, Slade School of Fine Art, London

AWARDS & RESIDENCIES
2008 Shortlisted, Jerwood Moving Image Awards
2007 Nominee, Hamilton Prize for Design
Process

Esther Teichmann

B 1980 Karlsruhe, Germany
2006-2009 MPhil/PhD Fine Art/Photography,
Royal College of Art, London
2003-2005 M.A Photography, Royal College of
Art, London
1999-2002 BA (hons) Visual Communication/
Photography, Kent Institute of Art and Design,
Maidstone

RECENT EXHIBITIONS
2008 Anticipation, Ultralounge, Selfridges,
London
2008 In Our World: New Photography from
Britain, Modena Civica, Italy
2008 Fragments, Galerie Karlheinz Meyer,
Karlsruhe
2007 Silently Mirrored, Man&Eve Gallery,
London
2007 Nature and Society, The Dubrovnik
Museum and The Glyptotheque, Zagreb
2007 Tagesstunde, Sassa Trülzsch Galerie,
Berlin
2007 The Region of Unlikeness, Bank Gallery,
Los Angeles
2007 The Esthacus Teichwynd Photos,
Collaboration with Spartacus
Chetwynd, Galerie Giti Nourbakhsch, Berlin
2007 Storytelling, Man&Eve Gallery, London
2006 Hyeres Festival, France
2006 Habitat, Phoenix Arts, Brighton
2005 Minus7/Plus 18, Lounge Gallery, London
2005 Made in Britain, Wetterling Gallery,
Stockholm
2004 Perspective, Ormeau Baths Gallery, Belfast

AWARDS & RESIDENCIES
2007 Man Group Award, The Royal College of
Art
2005 Creative Futures Photography Award,
Creative Review
2004 Guardian Student Media Awards
Photography
2004 Leica Prix, The Royal College of Art
2004 Fujifilm Student Awards

David Theobald

B 1965 Worthing, West Sussex
2006–2008 MA Fine Art, Goldsmiths College, University of London
2003–2006 BA (hons) Sculpture, Wimbledon College of Art, University of the Arts London

RECENT EXHIBITIONS & SCREENINGS
2008 Visions in the Nunnery, The Nunnery, Bow Arts Trust, London
2008 Locus, Fringe Arts, Bath Festival
2008 700IS Reindeerland, Culture Centre of Fljótsdalshérad, Egilsstadir, Iceland
2008 Monkeys with Car Keys, Bargate Monument Gallery (A Space), Southampton
2007 Artsway Open, Artsway Gallery, Sway
2007 The Sleep of Reason, Crawford Open, Crawford Gallery, Cork
2005 London Art Fair (Whitechapel Projects), London Design Centre
2004 The Big Art Challenge, Channel 5
2004 Raindance Independent Film Festival, UGC Trocadero, London

Jason Underhill

B 1982 Los Angeles, California
2007–2009 MA Fine Art, Goldsmiths College, University of London
2001–2005 BFA Fine Art, California Institute of the Arts (CalArts), Valencia

RECENT EXHIBITIONS
2008 Event Horizon, Temporary Contemporary, London
2008 Pick 4, The Apple Tree, London
2008 Calypso, Sala Rekalde, Bilbao, Spain (in Videoteque)
2008 Metamorphose, Islington Arts Factory, London
2005 House Party: Jenny, The Girl With No Eyes, Lime Gallery, CalArts, Valencia
2005 Traffic, Gallery D-301, CalArts, Valencia
2004 New York Independent Film Festival, New York
2004 Bijou Festival, CalArts, Valencia

Manuel Vazquez

B 1976 Bucaramanga, Columbia
2007–2008 MA Photography and Urban Cultures, Goldsmiths College, University of London
2006 SVA, Continuing Education, New York Photography
2001 MA Photography, EFTI, Photography School, Madrid
1998 BA Economics, Universidad de los Andes, Bogotá, Colombia

RECENT EXHIBITIONS
2008 Too Far South, Apt Gallery, London
2008 Open House Projections ICP, New York
2007 Getxo International Photography Exhibition, Getxo, Spain
2007 GENERACIONES, Casa Encendida, Madrid; Barcelona, Valladolid, Valencia and Seville
2007 Salón Fernando Botero, Bogotá, Colombia
2006 Souvenir, Galería Santa Fé, Bogotá, Colombia
2006 Frames, Colombian Consulate in New York
2004 PHotEspaña, International Photography Festival, Madrid
2003 Barcelona Contemporary Art Festival, Barcelona
2002 CANARIASMEDIAFEST, La Palma, Gran Canaries, Spain
2002 Autoridad Portuaria Bahía de Algeciras
2002 Woman and Society, Ayuntamiento de Vallecas, Madrid

AWARDS & RESIDENCIES
2004 Caja Madrid Scholarship, London School of Economics Seminars, Migration and Identity
2002 Francisco Jiménez National Contest, Madrid

Lara Viana

B 1970 Salvador, Brazil
2005–2007 MA Painting, Royal College of Art, London
1992–1995 BA (hons) Fine Art, Falmouth College of Arts

RECENT EXHIBITIONS
2008 Blyth Gallery, London
2008 Borrowed Time, Tricycle Gallery, London
2008 Contemporary Art Projects, London
2008 Shoreditch Town Hall, London
2008 My Penguin, 39 Gallery, London
2007 The Great Exhibition, Royal College of Art, London
2007 Contemporary Art Projects, London
2006 Matches and Petrol, A&D Gallery, London
2006 Taster, Hockney Gallery, Royal College of Art, London
2005 Afterimage, Phoenix Gallery, Brighton

Jane Ward

B 1960 Barnsley, Yorkshire
2004–2007 MA Printmaking, Royal College of Art, London
1997–1998 MA Fine Art, University of Central England, Birmingham
1979–1982 BA (hons) Fine Art, Coventry University

RECENT EXHIBITIONS
2008 One Removed, Unit2, London Metropolitan University
2008 00's Nature, Contemporary Art Projects, London
2007 The Great Exhibition, Royal College of Art, London
2007 Celeste Art Prize Finalists Show, Truman Brewery, London
2007 Kunstwurst, The Gallery, Southwark Park, London
2006 Parable, Temporary Contemporary, London
2005 Work in Progress, Hockney Gallery, Royal College of Art, London
2004 House Gallery, Camberwell, London
2004 Sartorial, England and Co, London
2003 Art Machine, Nadiff, Tokyo
2003 Gallery Artists, England and Co, London
2003 Outsized, MoDA, Middlesex University
2002 Narrative London, London Chamber of Commerce
2002 ARTfutures, Contemporary Art Society, London
2001 Transformer, Hat on Wall Gallery, London
2001 Camberwell School of Art, London
2001 DIY, Five Years, Underwood Street, London
2000 Cinch, London
1999 Subverted Suburbia, Gracefield Arts Centre, Dumfries and tour
1999 Conductors Hallway, Camberwell, London
1999 Bankside Browser, Archive and Internet project, Tate Modern, London
1999 Sense, Huyton Gallery, Knowsley, Merseyside
1999 Work inspired by Ranger's House, The Ranger's House, Blackheath, London
1998 Gallery 11, University of Bradford
1998 Invader, Levi's Gallery, Birmingham

AWARDS & RESIDENCIES
Terence Conran Foundation Award
Tim Mara Prize

Anita Wernstrom

Born 1980 Stockholm. Sweden
2004-2008 BA (hons) Fine Art. Slade School of
Fine Art. University College London

RECENT EXHIBITIONS & SCREENINGS
2008 Lorem Ipsum Gallery. London
2008 The Chelsea Arts Club. London
2008 Prisma Dance & Performance Festival.
Sweden
2007 Text. Image. Music – A Turtle Event.
Woburn Square. London
2007 Stroud Film Festival
2006 Art of Marching II. Vacio 9. Madrid
2006 Art of Marching I. Flimmer Film Festival.
Sweden
2006 TURTLE. An Anarchic Salon by Michael H
Shamberg. Chelsea Space. London
2005 FRAMED. Woburn Square. London
2005 Film 9. Arbetets Museum. Sweden

AWARDS & RESIDENCIES
2007 Chelsea Arts Club Trust Travel Grant
2007 The Slade Project Award

Paul Westcombe

B 1981 Inverness. Scotland
2005-2007 MA Painting. Royal College of Art.
London
1999-2003 BA (hons) Fine Art. Gray's School of
Art. Robert Gordon University. Aberdeen

RECENT EXHIBITIONS
2007 Jerwood Drawing Prize. London
2007 Mural Installation for NATO UK
Delegation. Brussels
2007 Hunters Moon. L'est Gallery. London
2007 Westies Wet Weekend. Royal College of
Art. London
2007 The Great Exhibition. Royal College of Art.
London
2006 Republic. L'est Gallery. London
2006 Spent. Three Colts Gallery. London
2006 Pleasure Yourself. Royal College of Art.
London
2005 Sex is Boring. Hockney Gallery. Royal
College of Art. London
2003 Royal Scottish Academy Schools Show.
Edinburgh

AWARDS & RESIDENCIES
2004 John Kinross Travel Scholarship
2003 John Philipson Memorial Medal

Jeanine Woollard

B 1978 Barnhurst. Kent
2005-2007 MA Fine Art. Goldsmiths College.
University of London
1997-2000 BA (hons) Fine Art. Middlesex
University. London

RECENT EXHIBITIONS
2008 In the Chapel in the Moonlight. E-Raum.
Cologne
2008 Pygmalion and Galatea. www.42x60.com.
Paris
2008 Working Men. Galerie Analix Forever.
Geneva
2007 Black Powder – White Party. Kyunghee
University Museum of Contemporary Art. Seoul
2007 Jungle Juice. EM Gallery. Seoul
2007 Air on the G-String. Galerie Analix
Forever. Geneva
2007 Future Film. Camden Arts Centre. London
2007 Video Evenings. Citric Gallery. Brescia.
Italy
2006 Rag and Bone. Three Colts Gallery. London
2006 Black Autumn Gold. Meals and SUV's.
London
2006 Survey. Whitebox Gallery. New York
2006 Handsome. Galerie Analix Forever. Geneva
2005 Total Recall. Alma Enterprises. London

ACKNOWLEDGEMENTS

For more than 20 years the annual exhibition has provided an overview of the best work of art students, as selected by a peer group – always of artists, sometimes abetted by writers or curators – from a national submission, which is open to every art school in the country.

The selection process is structured around peer group validation, involving the proper discussion of work and critical evaluation. It is a truly democratic process, which over the years has provided the first public showing for many of the country's most successful artists. At its heart, is the belief in providing an equality of opportunity for every individual who chooses to apply.

This year, the selection process was especially demanding. We received the largest submission ever, of more than 1,400 applications. It was a task that almost defeated the selectors (and organisers) in its scale and intensity; so huge thanks are due to Ken Lum, Richard Billingham and Ceal Floyer. Their generosity in the discussion of work and ideas is reflected in this year's exhibition, which features the work of 57 artists, in the largest show for some time. There is a much more open mix than usual of BA and postgraduate students, of regional and London colleges, of sculpture, painting, photography, printmaking and of video, sound and website projects, all of which promises to shape up into a very strong demonstration of young and new talent.

The exhibition launches as part of the Liverpool Biennial, in Liverpool's Capital of Culture year, in the A Foundation spaces on Greenland Street. It is the fifth edition of the Biennial and New Contemporaries has enjoyed being a part of it, since 1999. It is an association brought about by James Moores, who continues to play such a vital role in New Contemporaries. We are especially indebted to James Moores for the A Foundation's continued support. The exhibition will then tour to the A Foundation space in London, at Club Row, Rochelle School.

We thank our sponsors Bloomberg, who have supported us for the last eight years in our mission to provide the right conditions in which new artists and best practice can flourish. Bloomberg are rare as sponsors; they enable New Contemporaries to do its job, without compromise, in a shared belief of encouraging innovation. We thank Jemma Read and Anna Mandlik.

After a difficult year last year for many RFO's under the Arts Council's Review, we are delighted that the very necessary public funding of this project will continue for the next three years. We acknowledge the role of ACE North West in supporting New Contemporaries, in particular Helen Wewiora.

Next year is a landmark for New Contemporaries: 20 years since the first show of the current organisation and 60 years since Young Contemporaries was launched in 1949. The premise for the project remains the same today: to give an opportunity to young students to be recognised as artists and to make their work visible to the arts profession and to the public. Long may it continue.

Bev Bytheway, Administrator

New Contemporaries (1988) Ltd

Chair
Sacha Craddock

Vice Chair
Jill Ritblat

Company Secretary
Sue Prevezer

Directors
Eileen Daly
John Huntingford
Rebecca King Lassman
Des Lawrence
Mike Nelson
Andrea Schlieker
Nigel Spalding
Clarrie Wallis
Rebecca Warren

Administrator
Bev Bytheway

New Contemporaries
Rochelle School
Arnold Circus
London E2 7ES

0207 033 1990
www.newcontemporaries.org.uk

ISBN 978 0 9540848 8 2

Published by New Contemporaries
(1988) Ltd
© New Contemporaries (1988) Ltd

Catalogue edited by Bev Bytheway
and Eileen Daly

Photography: Stephen White
All other images supplied by
the Artists
Selection Photographs: Anna Arca,
Des Lawrence, Sacha Craddock

Design: Alan Ward
www.axisgraphicdesign.co.uk

Print and Reprographics:
Andrew Kilburn Print Services

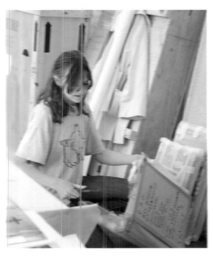
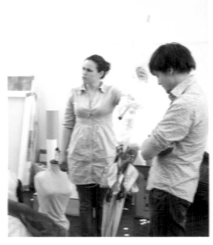